Digital Photographer's
Guide to Media Management

Digital Photographer's
Guide to Media Management

by Tim Grey

LARK BOOKS

A Division of Sterling Publishing Co., Inc.

New York

Editor: Mimi Netzel
Book Design and Layout:
Springhouse Studio
Cover Design: Thom Gaines
Associate Editor: Kara Arndt
Associate Art Director: Shannon Yokeley

Library of Congress Cataloging-in-
Publication Data

Grey, Tim.
Digital photographer's guide to media
management / Tim Grey.— 1st ed.
p. cm.
Includes index.

ISBN 1-57990-716-4 (pbk.)
1. Photographs—Conservation and
restoration—Data processing.
2. Picture archiving and communication
systems.
3. Image processing—Digital
techniques—Storage. I. Title.

TR465.G754 2006
775—dc22
2005031064

10 9 8 7 6 5 4 3 2 1
First Edition

Published by Lark Books,
A Division of Sterling Publishing Co., Inc.
387 Park Avenue South,
New York, N.Y. 10016

© 2006, Tim Grey
Photography © Tim Grey unless
otherwise specified

Distributed in Canada by
Sterling Publishing,
c/o Canadian Manda Group,
165 Dufferin Street
Toronto, Ontario, Canada M6K 3H6

Distributed in the United Kingdom by
GMC Distribution Services,
Castle Place, 166 High Street, Lewes, East
Sussex, England BN7 1XU

Distributed in Australia by
Capricorn Link (Australia) Pty Ltd.,
P.O. Box 704, Windsor,
NSW 2756 Australia

If you have questions or comments about
this book, please contact:
Lark Books
67 Broadway
Asheville, NC 28801
(828) 253-0467

Manufactured in China

ISBN 13: 978-1-57990-716-7
ISBN 10: 1-57990-716-4

For information about custom editions,
special sales, premium and corporate
purchases, please contact Sterling
Special Sales Department at 800-805-
5489 or specialsales@sterlingpub.com.

Dedication

To Tony Heller, a good man with a unique talent for organization.
He is missed.

Acknowledgments

I'm a remarkably lucky guy to be able to make a living doing the things I absolutely love. I fully recognize that achieving my dreams wouldn't be possible without the support and friendship of many people who have inspired me along the way.

My wonderful wife Lisa continues to put up with all the many projects I get myself involved in. I greatly appreciate her patience and support. She may be (sometimes) too modest to admit it, but I owe much of my success to her. I'm also inspired by Miranda and Riley to always do the best I can in everything I do.

In my writing, I greatly appreciate the support of Peter Burian, Jack Davis, Rob Sheppard, Chris Robinson, Ibarionex Perello, Steve Weiss, Richard Rabinowitz, Anthony Ruotolo, and Renee Costantini.

My life wouldn't be nearly as good as it is without great friends such as Bruce Heller and Jeff Greene. Thank you for your continued support.

Someday I might have the time to practice my photography enough to become as good as I would like. In the meantime, I am inspired by the remarkable photography of John Shaw, Art Wolfe, Dewitt Jones, Art Morris, Matthew Jordan Smith, Joyce Tenneson, and so many others.

Mike Tedesco (www.tedescophotography.com) provided a tremendous amount of help with the text and images for Chapter 5. Thanks Mike!

A huge thanks also goes out to Marti Saltzman for making this project happen and demonstrating incredible patience with the delays brought on by my busy schedule. Thanks Marti!

TABLE OF CONTENTS

Introduction

Digital photography has opened up a whole new world of possibilities for photographers. One of the best things about digital photography is that it removes many of the barriers—such as the sense that one is wasting film—that might have otherwise caused a photographer to limit the number of images they capture. This is truly a good thing, but it also leads many photographers to accumulate more images than they can manage to keep organized.

This book is for all digital photographers who have ever felt the frustration of not being able to find a particular image. (I suspect we have all known this feeling at some point.) My belief is that the sooner you start taking control of your images, the easier it will be to maintain a sense of organization. Then you can always locate an image when you need it.

Throughout this book, I'll be talking about the various ways you can ensure the safe and organized storage of your important images. My hope is that each chapter will help you gain a better understanding of the many issues involved with managing your growing collection of images, so you'll be able to create a system that works for you.

By having a well-organized media management system in place, your image workflow will go more smoothly and you might even find more time for taking new photos, which I think all of us would enjoy!

12
01

13
01

Chapter 1:
Storage Needs

Before you set out to create a perfect system for storing and organizing your digital images, it is important to give some thought to your needs, and to think about an appropriate storage strategy for your specific needs. In this chapter we'll take a look at the issues affecting digital photographers, and some of the things you should think about as you prepare to get your images safely stored and organized.

Digital Differences

We tend to think of digital photography as something we've all migrated toward from film photography. And yet, there are a surprising number of photographers who have never used film at all, having started in photography after digital cameras entered the scene. Of course, the vast majority of today's photographers have shot film in the past (and many still do), and even those who haven't understand the basic issues involved with film capture. Therefore, the many analogies used in the world of digital photography based on film capture make sense to the digital photographer.

Because most of us are very familiar with how things work when capturing photographic images on film, it makes sense to discuss some of the issues in the context of what is necessary with film to give a better perspective on what digital requires of photographers.

Frankly, with film photography the process of storing and organizing images is relatively easy. For those capturing with negative or "print" film, the strips of film typically remained in an envelope with the prints from the lab. To make it easier to find the right image later, you'd simply write a note about the subject matter on the envelope and file it away in a box or drawer. While this didn't provide tremendous flexibility in how you could track down a particular image, it did tend to help ensure that images of common places or subjects stayed together, and that the images would be in approximate chronological order, by virtue of the fact that you would tend to file away the envelopes filled with prints in the order in which the images were taken.

For photographers using transparency or "slide" film, a little more effort is often put into keeping images organized. That isn't universal, of course. Many photographers simply file away the sleeves or boxes of slides in a box or drawer, noting the subject matter of the photos on the sleeve or box. With this type of system, the results are much the same as those achieved by photographers using negative film.

Of course, professional photographers typically go a step further. Instead of leaving the processed slides in the original sleeves or boxes, they utilize a filing system for their images to keep them better organized. The slides are taken out of the sleeves or boxes the lab placed them in and sorted by subject matter. The specific system of organization varies by photographer, who might choose to sort the images by location, client, subject matter, date, or any other categorization that makes sense to the individual.

This filing system helps keep the images organized, but without the ability to apply simple cross-referencing, since an image can only be in one place at a time. When the time comes to find a particular image, you must remember how it is categorized so you'll know where to look for it.

Digital Advantages

Digital offers a number of advantages over film. While a single image on film can only be stored in a single place, a digital image can be copied to multiple locations, or even better, can be saved in one location and referenced in multiple ways using software. This allows significant cross-referencing of images, so an individual photo can be located based on a variety of different clues, rather than requiring the photographer to remember the single category under which an image was filed.

The ability to copy digital images and produce an exact duplicate also provides the benefit of an effective backup to help you protect your images. (I'll talk more about backing up your digital photos in Chapter 7.)

Digital cameras offer a number of advantages to photographers, which is part of the reason they have become so popular.

With film, it's not easy to produce an effective backup copy of your images. Sure, you can have a duplicate made, but the quality is not up to the level of the original. As film scanners improved in quality, scans became a way to backup the original piece of film, but that falls into the category of an advantage provided by digital.

Besides these basic advantages, digital offers a tremendous ability to organize your images using a variety of techniques from simple file management with your computer's operating system to advanced image management software. This allows you to categorize your images, apply keywords, and then search for images using those factors or other information such as the metadata stored in the images (which I'll address in Chapter 5).

Digital Disadvantages

As you can imagine, or as you may have already experienced, the advantages of digital do come with a price. Part of that price is the money you need to spend to take advantage of digital. That means buying a new digital camera more frequently than you would have replaced a film camera, upgrading or replacing your computer so you can work efficiently with the ever-growing number and size of your digital images, and buying more and more hardware and media with which to store your images.

Another cost of digital is the additional time required to work with and manage your images. Part of that time is spent optimizing the images, which provides a tremendous benefit in the added control we can exercise over our images. Managing images also takes time, but it allows you to be much more organized with your images, so you can always find just the right image when you need it. Again, this results in a significant advantage for the photographer if used properly, but there's no question you'll spend more time maintaining this system. At times it may seem that you're investing far too much time in managing your images, and for many photographers that's probably true. I'll discuss some of the tradeoffs in the various options available to you in Chapters 4 and 5.

One of the other disadvantages of digital is something I consider to be a "dirty little secret" in the digital photography industry. In short, digital images have a greater risk of getting lost than their film counterparts. There are three basic categories under which I think about image loss in this sense.

The first is not a literal loss of the image file, but rather an inability to find that file. Considering you're reading this book, you've probably become frustrated at one point or another at your inability to locate a particular image file. As the popularity of digital photography grows at an amazing rate, so does the rate at which digital photos are accumulating. In all too many cases, those images are simply dumped somewhat haphazardly onto a folder on the computer's hard drive with little thought to organization. Before long, you don't know where any of your images are. This is a type of loss you can avoid or overcome using the methods discussed in this book.

One of the most significant challenges of digital photography is the fact that the images accumulate so quickly. It can be nearly impossible to find the image you are looking for in a folder filled with many images.

The second type of loss is when media becomes outdated. If you've been working with computers for any length of time, you probably remember the 5.25″ floppy disk. The 3.5″ floppy drive is similarly fading into oblivion and it is getting increasingly difficult to find a drive that will allow you to read this media. There have been some digital cameras, most notably the Sony Mavica line, that captured images directly to 3.5″ floppy disks. Chances are it has been a while since you've seen a floppy disk or drive, and if you have any images stored on that media, you may have a difficult time accessing those images.

Similarly, the storage media we think of as firmly entrenched today may be obsolete in the future. DVD media is gaining ground on CD storage because of the greater capacity it offers. Hard drive technology

will certainly evolve to the point that current drives aren't readable at some point in the future. These changes occur gradually over time, so that they can be addressed. The key is to pay attention so you will be able to transfer images from media that is becoming outdated to the latest media types.

A consideration similar to the issue of outdated media is the issue of outdated file formats. Just as new and better storage media will replace what we are currently using, you can be assured that file formats will change. You may be familiar with the bitmap (BMP) image file format that was very popular among many graphics applications several years ago. That file format has since been effectively replaced by file formats, such as TIFF, JPEG, and even GIF. With time, better compression methods, higher bit-depth, greater dynamic range, and other features will be supported by new or updated file formats. As new and improved file formats gain acceptance, older formats fall out of favor, which leads to a lack of ongoing support. Again, these changes occur over a period of time, but it is important to consider these issues as you maintain your digital image library.

The third type of loss is most severe: the permanent loss of image files. Media failure is not terribly common, but it does occur. Files can become corrupted. Also, if you don't manage your image files you may accidentally delete files. Fortunately, this is a form of loss you can avoid by organizing and backing up your image files.

The bottom line is that digital photography often requires a greater investment of time on the part of the photographer. You'll have to organize, backup, and maintain your storage media and file formats over time, making sure they remain accessible in the long term. This is a big difference between digital and film. All you need to do is ensure the physical security of film and you can count on the image being available for many decades. There are, of course, many benefits to investing time in media management, but the fact remains that you'll need to spend more time to achieve many of the benefits of digital.

Thinking about some of the issues related to digital photography may let the wind out of your sails. However, my guess is that you already knew about many of these issues, which is probably

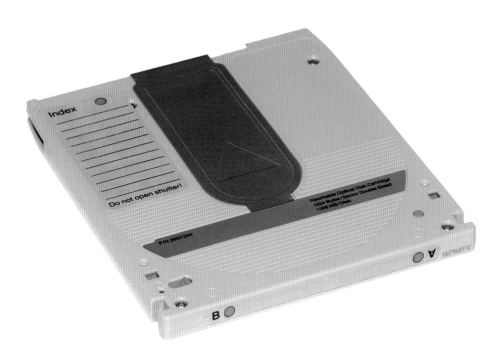

You may not be familiar with this media type, though it was in common use less than a decade ago. It is important to maintain current storage media so your digital images can be accessed decades into the future.

why you're reading this book. My feeling is that it is important to understand the pitfalls so you can avoid them. Fortunately, all of the challenges I've outlined above can most certainly be overcome with a wise approach to media management. Throughout this book I'll be providing exactly the information you need to ensure you are able to find your images when you need them, and that the files are stored safely for decades to come. It will require a little bit of work on your part, but I can assure you that you'll enjoy the benefits of investing that effort. Your images are most certainly worth it.

Storage Considerations

It is important to give some thought to your storage needs now and in the future as you create a storage plan for your image files. This includes considering what files you need to save, how much storage space you'll need, and whether you need your data to remain portable.

What to Save

In order to make a plan for your storage, you need to think about what you'll be saving. Naturally, there are many files stored on your computer, from the operating system to applications, as well as a wide variety of documents and media files. For the purposes of this book, we're only considering your digital images.

Deciding what you really need to save and what might not be necessary is an important first step in determining your true storage needs.

Original Captures

Regardless of anything else you save (and there will be other image files that need to be saved) I always recommend saving your original files right out of the camera. Whether you're capturing in RAW, TIFF, or JPEG, those files are your "originals" from the standpoint that they represent what the camera originally recorded. That doesn't mean that the original capture is necessarily the optimal version of the image, but it does represent the unadulterated starting point, and it is important to retain that.

Preserving the original capture provides a form of backup, so that if you lose other versions of the file you've spent time working on you can always go back to the original and start over. This is also helpful in situations where you feel you can get a better result than you originally did. For example, if you upgrade your software or learn new image-manipulation techniques, it might be worthwhile to return to that original file and start over with the conversion and optimization process.

I think all photographers can appreciate the importance of saving your original slide or negative. In a similar vein, I always recommend preserving the original digital capture. You may never need to go back to it after creating an optimized version of the original, but if you ever do need one you'll be very glad you saved it.

Master Image Files

I use the term "master image file" to refer to the file that results when you have optimized your image to perfection. I recommend using multiple adjustment layers and image layers as appropriate for your workflow, so that the background image layer in your document represents the starting point (or the starting point right after

The master image file that contains all of your adjustments and the original pixel values is one of the most important image files to save.

converting the RAW image in the case of RAW capture). This allows you to go back and fine-tune the adjustments you made without compromising image quality, which is a significant advantage. It also means these files will likely be quite large. However, my feeling is that the advantages provided by this workflow far outweigh the significant storage requirements that result.

It could be argued (and I would tend to agree) that these master image files are even more important than the original captures. If you follow a non-destructive workflow for optimizing your images, the master image file will contain both the original pixel values and the adjustments applied to them. It will become the source of all output you may produce from a given image. These files would typically either be saved in a TIFF file with layers, or the native file format of the software you're using, such as Photoshop PSD files if you're working with Adobe Photoshop.

Additional Files

The original captures and master image files are the most important files to save from the standpoint of preserving your important data. However, there are also other files you will want to save as you continue working with your images.

For those who like to explore the creative possibilities with their photographs, there may be multiple versions of an image with different creative effects applied. For example, you might produce a black-and-white version of an image, a sepia-toned version, and versions of the image with various artistic filters applied. You would want to save each of these versions (at least those you're happy with) to ensure you're able to produce output from them just as easily as you could from your master image file.

You may also prefer to save versions of your files that are ready for output. For example, in the output workflow I recommend you work on a duplicate copy of your image, flatten all adjustment and image layers, resize as appropriate for the output you're producing, and apply sharpening. The result is an image file that is ready for the output you're creating, such as a print. You may want to save this final output version of your image to allow you to create additional images—either prints or duplicate files—of the same size and type easily in the future. For

photographers who tend to produce a large number of prints from the same images, this can be a huge benefit in terms of efficiency. Instead of preparing the image for output every time you need to make a print, you can simply open the appropriate output version of the file and print it.

These additional versions of your image files do have the potential to consume a considerable amount of additional storage space. For that reason some photographers may not want to save these additional files. It comes down to weighing the cost in storage against the benefit in convenience. If you're producing multiple versions of an image, you might consider whether you really need (or even like) all of them. You might also utilize Layer Groups in Adobe Photoshop, for example, to allow you to create multiple versions of an image in the same document for greater efficiency in terms of overall storage requirements.

As for files prepared for specific output, you'll need to decide whether the time saved by having, for example, a file that is already prepared for an 8 x 10-inch print on your photo inkjet printer is worth the extra space it consumes. This is simply a matter of evaluating how many prints you're making. For photographers who don't really market their prints for sale, the benefit of having a file prepared for a specific output size and type may not be worthwhile. For photographers repeatedly selling specific images at specific sizes, this can be a huge advantage.

Capacity Requirements

Once you have a sense of the number and types of files you'll be saving, you can start thinking about how much storage space you'll need to save your images. While you can always add more storage later, this is an important consideration as you're making a storage plan. It isn't necessary to calculate a precise value here, especially because it is virtually impossible to anticipate the actual growth of your image library, but you want to at least have some concept of how much storage you'll require. This will impact the decisions you make about storage media.

Current Needs

Figuring out your current storage needs is largely a matter of taking inventory of your image files. You may have duplicate files, various media types stored in multiple locations, more than one computer with images stored on the internal hard drive, and many other factors that make this inventory process a bit of a challenge. However, I still strongly recommend that you go through this process so you'll have a better understanding of your needs, both in terms of capacity and organization. (Artistic types, such as photographers, have a reputation for being disorganized, so don't worry if you feel that your current image storage is in complete disarray. The purpose of this book is to help you get a handle on your images.)

So, grab a notepad and pencil, and start tabulating your current storage, using round numbers and estimates to get an approximate total. Check all the media you are currently using for storage, and create a list of the total storage space you're using.

Let's take a look at one possible situation to give you a sense of how this process would work. We've concocted a photographer we'll call Bruce who has images spread across various storage media. First he checks the various folders on the internal hard drive in his computer to see how much space is being used there. This is done by checking the folder properties for the main folder where all images are stored or for individual folders if they're scattered around the hard drive. Let's assume Bruce discovers he is utilizing about 3 gigabytes (GB) of storage for images on his internal hard drive.

Bruce then moves on to his collection of images archived on CDs. He has a total of 28 CDs with images on them. There's no need to put each disc into the computer's CD drive to find out how much space is used on each. Instead he just assumes they'll have about an average of 500 megabytes (MB) out of a total of 700MB available on each disc. For 28 discs, that would total another 14GB of images.

Of course, as DVDs entered the scene Bruce started storing images on DVDs because they offer a higher storage capacity than CDs. This was a relatively recent switch for him, so he only has five DVDs with images on them. He assumes he probably has about 4GB (out of a total capacity of almost 5GB) on each DVD disc, so that's another 20GB.

Recently, Bruce began to centralize all his storage onto a large external hard drive connected to his computer. He hasn't yet moved the images from his other media onto this external hard drive, but he has gotten in the habit of putting all new images onto this drive. He checks the folder properties for the hard drive and determines that he has saved about 67GB of images on this drive.

Adding up the data from each of these storage locations, Bruce comes up with a total of about 104GB of storage being utilized currently. You can go through a similar process to get a sense of your current storage needs. This will give you a baseline number for the amount of storage you need to meet your current needs. Of course, you obviously already have that much space available since your images are currently stored on the various media you're utilizing, but knowing how much space you currently use will enable you to better decide on the best storage strategy moving forward.

Projected Growth

Understanding your current storage needs is important, but you also need to take into account the rate at which your storage needs will grow. This is a more difficult calculation to make than your current storage needs, since it is based largely on assumptions. However, the rate at which your storage needs will grow over time is an important consideration as you develop a storage strategy.

This process is similar to calculating your current storage needs, except that you're making calculations based on your behavior rather than your existing storage utilization. Let's use another sample photographer, who I'll call Lisa, and see how this might progress. Lisa typically goes on two extended photo trips each year, each lasting about two weeks. She also makes many smaller trips throughout the year, which total the equivalent of an additional five weeks. So, she spends a total of about 50 days photographing each year.

When she's out taking pictures, Lisa typically fills up four CompactFlash cards with a capacity of 2GB each day. That totals 8GB per day. Multiply this by the 50 days she'll spend photographing each year, and Lisa can expect to accumulate about 400GB of images per year.

Lisa also needs to consider how much additional space she'll require for the master image files she'll produce from her favorite photos. She estimates that from each day's shooting she will only optimize four images. While the final size may vary, she tends to end up with a master image file of about 200MB from each of those images. So, with 50 days of photography and four optimized images per day, that's 200 images. At a size of about 200MB each, that would total about 40GB of storage.

Adding the estimate for captures and master image files, Lisa needs storage for about 440GB each year.

Total Storage Needs

The current storage and projected growth values determine how much storage capacity is required to provide adequate storage for existing images and photos that will be taken in the future. For example, if you have current storage of about 250GB, and you expect that volume to grow by about 250GB each year, you'd need 500GB of total storage to ensure you have enough capacity for the next year, or 750GB to get you through the next two years, assuming your photography habits don't change significantly in the meantime.

Because all types of technology, including storage, change so quickly, I recommend you only extend your storage calculations out for the next 12 to 18 months. This allows you to meet your needs without committing to a solution that may not meet your needs in the long term. You can then re-evaluate your storage requirements from time to time, and make a decision about whether to add storage of the same type or transfer your storage to a media of a different type or higher capacity.

Another factor to consider for overall capacity is adequate space to create a backup copy of all images. Backing up will be covered in detail in Chapter 7.

Portability

It is also important to consider the potential need for portability in your image storage. This isn't a need for all photographers, but it is something that can potentially offer advantages even for those who don't find it necessary.

There are two basic ways to store your images on a computer. The first is to utilize storage devices that are inside your computer. These would typically be hard drives contained within the computer case, and while they could be removed and taken elsewhere, that isn't exactly a convenient solution.

The second method is to utilize media that is kept separate from your computer, which enables you to move it with relative ease from one computer to another. It also enables you to store a second copy of important images at a separate physical location for added peace of mind. Examples of this are optical media such as CDs and DVDs; external hard drives, which are the same type of drives you would normally have inside your computer, but contained in a separate package and connected to your computer via a cable; and various other peripheral storage devices.

My preference is to always utilize portable storage for digital images. The advantages include the following:

- The ability to easily take images to another computer at a different location, for example to deliver a large volume of images to a client.
- Easily upgrade to a new computer by keeping copies of all your important images (and other files) stored separately from your old computer. All you need to do is attach or insert the media and you'll have immediate access to your images.

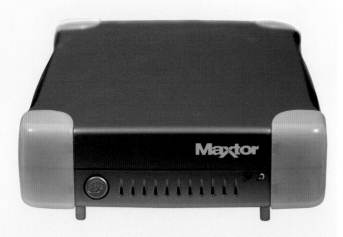

By using media that is separate from your computer, such as this external hard drive, you can ensure the portability of your image files.

⊃ A convenient way to provide an offsite backup solution, since you can remove the media and take it elsewhere very easily.

Of course, there is at least one disadvantage to consider with portable media. In general, portable media will not perform as fast – and in some cases will perform considerably slower – than the internal storage in your computer. This can be an important consideration for those who need to transfer a significant volume of images. You can work around this issue by transferring the images you'll need to work on to your internal storage before starting a project, but you'll still need to consider this potential drawback as you consider the need for portability in your storage solution.

Availability

Having thought about the various issues related to your storage needs, the final consideration is the way you'll access your images, and whether you need them to be available full-time.

Full-Time Availability

Naturally, you'd probably like to have immediate access to every single image in your growing library at any given moment. That is certainly a worthy goal, and with proper planning it can be achieved.

The most basic requirement for full-time availability of all your images is adequate storage capacity utilizing storage devices that are always "live". This could be the internal hard drive in your computer (though capacity will likely become a limitation over time) or a series of external hard drives. CDs, DVDs, or other removable media are not a viable solution because you can only have one disc in the drive at a time. Therefore, if you're going to strive for full-time availability of all your images, you'll need to utilize storage devices that are connected to your computer (even if that is indirectly through a network connection) on a continual basis.

Even if you don't think you'll have a real need for full-time availability, I would recommend that you consider planning for this ability anyway. You're going to need the same amount of storage regardless, so the only difference here is in the type of media

you utilize for storage. Having all images available to you at any given time can be a great advantage to a photographer.

Archival Storage

For those photographers who don't feel the need to keep all their images available at all times, or who don't need to access their older images with any real frequency, adopting an archival storage solution may be best. In this approach, images that are needed immediately or used frequently, such as your most recent images and your all-time favorites, are kept on local storage with full-time availability. Older images or those you don't anticipate needing anytime soon could be moved to an archival storage that isn't kept live at all times. These files can be stored a bit more securely, even at an offsite location, so they'll be safe for many years to come. The obvious drawback is that it isn't as convenient to access the images in your archival storage when you need them.

Making a Plan

You should now understand how to plan your storage needs, which will be very specific to the way you work with your images and how many new images you tend to capture each year. With an estimate of how much storage capacity you need and the strategy you want to use for that storage, you can start to think about the specific media you should use for that storage.

photo © Mimi
Netzel

Chapter 2:
Storage Options

The last chapter introduced you to the issues to consider when evaluating your storage needs. Now that you have a sense of what your needs are, you can work toward meeting those needs by purchasing appropriate storage hardware and media. In this chapter I'll look at the various options available, providing you with information to help you make a decision about the best solution for your specific needs.

Storage Media

There are many choices available to you when considering storage media, which can be both good and bad at the same time. It is good because it means you have more options, and therefore a better chance of finding a solution that will best meet your needs. It is bad because it means you have to wade through more options in order to find the right solution.

The sections below will discuss the most common options available to you, providing information on the various benefits of each media type, as well as the factors you want to consider when selecting a specific device or media in each category.

Internal Hard Drive

When it comes to internal hard drives, it isn't so much a question of whether you will have one, but rather how you'll put it to use. I still (barely) remember the days when computers didn't come with hard drives at all. Both programs and data were accessed from floppy disks. Now internal hard drives are standard equipment, so the only question is whether you'll use it as your primary method of storage, a part of your overall storage system, or not store your images on it at all, keeping those on external media.

While the existence of a hard drive in your computer is a given, the specifications for the drive (or drives) is something you'll need to consider when purchasing a new computer, or even when upgrading your existing computer. Some of the key factors you need to think about are capacity, speed, and RAID configuration.

This chapter focuses on the hardware and media you'll utilize at your location, and doesn't address storage on remote systems, such as via the Internet. That solution will be discussed in Chapter 6.

Capacity

When it comes to capacity for your internal hard drive, my general recommendation is to get the highest capacity available. Even if you aren't going to use the internal hard drive for primary storage of your images, you'll likely consume a significant amount of space with the operating system and the various applications you'll install. Even if you're not planning to use your internal hard drive space for primary storage, if you have space available it can most certainly be used as an additional backup.

Hard drives have become so inexpensive that it makes sense to just get the largest available. Maximum hard drive capacity changes rapidly, and it's easy to put off your purchase knowing that soon there will be a new model with a faster processor and a larger hard drive. Technology allows hard drive capacities to increase while the price per gigabyte continues to drop. Just accept this, do your research, and make your purchase. Otherwise you'll always be waiting when you could be working more efficiently.

However, if you're not going to use the internal hard drive for primary storage and want to keep the cost of the drive to a minimum, you can opt for a smaller internal drive. Typically, this will be more than adequate for the operating system and applications, but may not offer an adequate amount of available space for storing your image files.

As you probably learned from Chapter 1, you'll likely need a considerable amount of storage for your images. If you'll be utilizing the internal hard drive for that storage, you'll likely need more available space than the minimum available in today's computers. With drives as inexpensive as they are, I highly recommend simply opting for the highest capacity drive you are able to get when purchasing a new computer, and when space becomes short on the drive in your computer consider replacing the internal drive or supplementing it with the highest capacity external drive available.

Speed

Considering you'll be storing large files, and probably a large number of large files, and also considering the high performance demanded from computers used for digital imaging, you want to consider the speed of the hard drive you'll utilize in your computer. There are a variety of factors that affect overall hard drive performance, with the following being the most important:

Interface—The interface is the way the hard drive connects to the computer, and it plays a significant role in the performance of the drive. I recommend using drives that connect via a Serial ATA (SATA), which offers optimal performance while being incredibly simple to manage.

Sustained Transfer Rate—In terms of the drive performance specifications, this is the one I consider most important. The sustained transfer rate tells you how much data can be moved over a given time on a sustained basis (as opposed to short bursts). I look for drives with a sustained transfer rate of 150MB per second or greater.

Spin Rate—The spin rate, as the name implies, is a measure of how quickly the platters (which are what the data is actually stored on) spin inside the drive. Most high-performance drives spin at rates of 7200 or 10,000 revolutions per minute (RPM). Newer drives that offer 15,000 RPM are starting to appear. While this isn't the only factor that affects drive performance, it is a good benchmark to reference.

Average Seek Time—The average seek time represents how long it will take the drive, on average, to move the read/write head to a specific point on a given platter within the drive. The lower the time, the faster the head can access a given point, which again is a general measure of overall performance. I generally look for drives with an average seek time of less than 10 milliseconds (ms), with lower being even better.

As you can probably appreciate already, faster hard drive performance is always a good thing. By using the specifications above, you can be sure you'll get the best performance possible from your internal hard drive, which is important even if you're not using that drive as a primary storage device for your images, since hard drive performance can play such a critical role in overall system performance, application load time, and the time required to open and save files.

RAID Configuration

RAID stands for Redundant Array of Independent Disks, and it is a way to "string" multiple drives together to achieve either a performance or data safety benefit. I generally recommend taking the route to optimize performance, especially if you're storing most of your images on an external drive and are very good about backing up your images regularly.

The performance benefit is possible with RAID by utilizing two drives to appear as a single drive to the computer, which is a RAID-0 configuration. When you save a file the data is broken up into packets. Think of those packets as being numbered sequentially, so there are both odd and even numbered packets. The RAID-0 configuration stores the odd-numbered packets on one drive and the even-numbered packets on the second drive. This configuration writes data to both drives at the same time, and results in improved performance for writing data to as well as reading data from your hard drive storage. The improvement won't be double, but it will be significant. This can dramatically reduce the time required to load applications or open and save individual files.

When saving large files you'll appreciate the benefits of a fast storage solution.

Configuring a computer with RAID-0 does require that you have a minimum of two hard drives installed (though you could also utilize more), and that you include a drive controller that supports RAID. This can increase the cost of your computer, so you'll need to decide for yourself whether the performance advantage is worth the additional cost. I do feel that it is well worth the additional cost for the computer, but you'll have to decide for yourself whether you're willing to pay extra to achieve improved hard drive performance. Many computer manufacturers are offering RAID-0 as an option on their higher-end computers, and considering the performance advantage this is something I recommend taking advantage of.

The next option is RAID-1, which provides drive "mirroring." In this configuration, two drives are used, similar to a RAID-0 configuration. However, instead of alternating data between the two drives to achieve a performance advantage, the same data is written to both drives simultaneously to achieve a data redundancy advantage. In effect, RAID-1 provides an automatic backup every time a file

is saved. This is a great advantage, but there is still the risk that if your computer is destroyed, both drives (primary and backup) will be lost. Not likely, but something to keep in mind. Even with this form of data redundancy, I still recommend having a strong backup system in place rather than relying on RAID-1 as your backup solution.

The other option I'll mention is RAID-5. This combines the benefits of RAID-0 and RAID-1 in a single configuration, with a requirement that you utilize a minimum of three hard

From a statistical perspective, using RAID actually increases the risk of hard drive failure. You are utilizing more drives and therefore your exposure is increased (just like the more lottery tickets you buy, the more likely you are to have a winning ticket, even if the odds are still very small). For that reason, if you employ RAID it is still important that you backup your images to separate media.

drives. The result is an improvement in overall read and write performance while maintaining data redundancy. This redundancy is not the same as drive mirroring, but the net effect is the same. While this is an excellent solution, it doesn't eliminate (in my opinion) the need for a backup system, so I prefer to focus instead on the performance advantages (and lower cost) of RAID-0 and to maintain a good backup at all times.

CD

I certainly don't need to tell you what a compact disc (CD) is, as they have become incredibly ubiquitous. This makes them an attractive storage method, because you can be assured that virtually anyone on any computer can read the data from the disc if needed. This has also led many photographers to utilize CD media for primary storage, though many have stopped doing so simply because the 700MB capacity typically offered isn't very much considering how large the files we work with have become. However, CDs are still useful for sending files to clients or friends, so it is important to understand the various issues that are important for this storage format.

CD is a removable media storage solution, which means the storage media is separate of the drive used to read and write that media. The drive determines the speed at which you're able to read and write the discs, but it is also important to understand the various media options available to you.

Media Options

With CD there are two basic media options. The first option is CD-R media, which stands for Compact Disc-Recordable. These are standard discs for writing data, and the only format I recommend. The disadvantage often perceived as being an issue with this media type is that you can only write the data once. However, considering that CD media is generally used for sending files to someone on a one-time basis rather than for archival storage, and because they have gotten to be so inexpensive, I don't consider this a major concern.

The other option is CD-RW or Compact Disc-ReWriteable. This media type can be written and re-written to many times over. On the surface this makes CD-RW media very attractive, because it could be used in situations

where you want to be able to update your saved images or use the disc repeatedly in a backup scenario. The problem is that CD-RW media is relatively unreliable. Because of the method it utilizes for storing bits on the media, with the need to change values easily, CD-RW media is especially vulnerable to data loss caused by exposure to extreme temperature or humidity, or even bright light. I strongly recommend avoiding CD-RW media, opting for CD-R media if you deem CDs to be appropriate to your needs.

Compact Disc (CD) media have become ubiquitous for digital file storage.

Speed

The speed of a CD writer (also referred to as a CD burner because a laser is used to burn the data onto the disc) is described using an "X" system, where X is equal to 150 kilobytes (kB) per second. Early CD writers were simply 1X meaning they could record data to a CD at a rate of 150kB per second. Of course, since that system was devised the performance of drives has improved considerably, with the latest drives offering much higher speeds.

Most of today's drives are able to achieve read and write speeds for CD-R media at around 48X, which represents a potential data transfer speed of about 7MB per second, requiring just over a minute to write enough data to fill a CD-R disc. I consider this measure of performance to be the most important technical specification for CD drives, and the faster the better if you need to frequently burn CDs for backup or to send out.

You'll usually see drive specifications listed with three speeds, such as 48X/24X/12X. When three numbers are listed, the read speed is first, the maximum speed for writing to CD-R media is second, and the

maximum speed for writing to CD-RW media third. More recent drives may only provide a single number, which generally means the drive is able to read CDs and write to CD-R discs at the same speed, while writing to CD-RW media will be at a slower speed (which is often not referenced at all).

DVDs

DVD is an acronym for Digital Video Disk although DVDs are not just for video. In many ways you can think of DVD as being a CD with a higher capacity. In fact, many people wouldn't be able to tell the difference between the two without looking at the label because the discs are the same size. The only real difference in many ways is the capacity, with a typical one-sided, single-layer DVD offering 4.7GB of storage. Two-sided or multi-layered discs with even greater capacities are becoming more widely available.

Because of their higher capacity, DVD media makes much more sense than CDs for photographers wanting to store images on this type of removable media. Like CDs, DVDs offer a great way to send a relatively large number of images to clients who need to review

your images. However, 4.7GB isn't really a huge amount of storage space by today's standards, so it is still not an ideal solution for most photographers. Even if you aren't going to use DVD for primary storage, you'll probably want to utilize DVD at some point for sending files to someone, so it is important to understand the issues related to using this media format.

Media Options

One of the most significant challenges has been the competing DVD formats that have often introduced compatibility problems. Fortunately, the number of DVD media formats in use has decreased from five common formats to only two common among most users today. Those two formats are DVD-R and DVD+R. While a growing number of DVD drives are able to read and write both formats (generally referred to as DVD+/-R drives), the presence of different media formats still represents a decision you must make.

Since this is becoming less of an issue thanks to a growing number of drives that support either format, you will likely experience situations where a client is only able to read DVD media of a specific type. Frankly, I don't consider

DVD is virtually identical to CD media except that it is able to store a much higher capacity, with current discs offering 4.7GB of data storage.

there to be any advantage to either DVD-R or DVD+R media, so the choice is largely arbitrary. However, if you'll be sending images to clients on DVD, it is a good idea to find out what formats they can read, and make your decision on what to purchase accordingly.

Speed

The speed issue for DVD media is very similar to CD, in that it utilizes an "X" rating. However, the specification is different for DVD, with 1X representing a data rate of about 1.3MB per second. This makes it nine times faster than 1X would be for CD media, so if you're used to the ratings for CD drives, you can multiply the DVD rating by nine to get the equivalent CD speed rating (for example, a 1X DVD drive transfers data at the rate of a 9X CD drive, a 2X would equal an 18X, etc.). The current high-end DVD drives are able to read and write data at a rate of 16X, which is the equivalent of 144X for a CD drive.

As you can imagine, I recommend getting the fastest DVD drive available if you'll utilize this format. Especially because DVD media stores more data, writing data to fill a DVD takes longer than it would for a CD. At 16X, for example, it would take 4 minutes to fill a DVD.

External Hard Drive

External hard drives offer a number of advantages over other media, primarily in terms of capacity, performance, and portability. For this reason, they represent an excellent solution for both primary storage and backup purposes.

Capacity

As you learned in Chapter 1, it doesn't take long for most photographers to accumulate a need for significant storage space for their digital images. For this reason, capacity is often the first consideration when it comes to deciding on an appropriate storage solution. This is an area where external hard drives offer a considerable advantage, similar to internal hard drives.

In fact, an external hard drive is basically an internal hard drive housed in a casing that provides the data and power connections. While I still recommend getting the highest capacity drive possible—just like with your computer's internal drive—that sometimes translates into getting the highest capacity drive that fits your budget. And, of course, you should consider your current and projected storage needs.

The maximum capacity of external drives has recently grown quite rapidly. This is due in part to developments in hard drive technology, but also because recent drives put multiple hard drives in a single case to create a drive that "looks like" a single large drive to the computer.

> I consider external hard drives to offer the best combination of capacity and performance with the benefit of portability, and I recommend them as the best storage solution for most photographers.

At this writing, current external hard drives offer capacity that ranges from around 40GB at the low end, up to 1 terabyte (TB), which is the equivalent of 1000 GB. I would venture that for the "typical" photographer (recognizing that there really is no such thing as typical) a 300GB external drive will provide adequate storage for current and future storage for a good year or more. Of course, there are many photographers who need considerably more storage, so it is important to evaluate your needs before making a final decision.

Interface

The interface is the way the external hard drive will connect to the computer for purposes of transferring data. It is an important consideration both because you'll need to make sure your computer has a port of the type required by the external hard drive you purchase. If not, you can most likely add a port for your computer to meet the requirements of the drive you're using.

The other important consideration when it comes to the interface is the performance of the drive. Each interface type has an upper limit on how fast data can be transferred, and it is altogether possible that this will create a bottleneck for performance. The following interface options are currently employed by external hard drives:

USB 1.1 – This is the most ubiquitous connection interface of those used for external hard drives, but it doesn't offer very fast performance. The maximum theoretical data transfer rate for USB 1.1 is 1.5MB per second, which is very slow by today's standards for digital photography. While you may have to resort to using a USB 1.1 connection from time to time because of a computer limitation, I would strongly recommend that you not purchase an external hard drive that offers this as the only interface option.

USB 2.0 – As the name implies, this is an update to the USB 1.1 specification. It utilizes the same port for connections, but offers a significant performance improvement. For USB 2.0 the maximum theoretical data transfer rate is 60MB per second. This is a comfortable transfer rate for most photographers, and considering the ubiquity of USB 2.0 ports on current computers, represents a good choice.

IEEE 1394a – This interface is often referred to by the name FireWire or FireWire 400. It offers very good performance with a maximum theoretical data transfer rate of about 50MB per second. That puts it slightly below USB 2.0 on performance, but because of the increased overhead of USB 2.0, in actual use IEEE 1394a generally offers similar performance. While IEEE 1394a has been standard

equipment on Macintosh computers for some time, it is not as common on Windows PCs. As such, you may need to install an add-in card if you want to utilize this as the interface for your external hard drive.

IEEE 1394b – The IEEE 1394b interface is often referred to as FireWire 800, and it is an update to IEEE 1394a that offers a considerable performance advantage. The maximum theoretical data transfer rate is about 100MB per second, making it the current best-choice for external hard drives. This is the interface I recommend utilizing for photographers with a significant volume of images, even if that means adding a IEEE 1394b card into the computer.

Bus-Powered Drives

External hard drives by their nature offer a certain degree of portability. While they need to be connected to a computer and a power source, there is the option of using the same connection to the computer for both data and power. This is an attractive option for those requiring a higher degree of portability. Such drives are generally referred to as bus-powered

drives, because the computer connection (bus) provides the power to the drive.

Such drives are especially helpful for those who want to carry their storage to client meetings or into the field. Instead of carrying around a power cord that might even include a relatively heavy transformer, you can carry just the drive itself with a data cable. These bus-powered drives also utilize hard drives with a smaller form factor, adding to their portability. This does, however, introduce the drawback

Bus-powered drives provide the convenience of not requiring an external power source, as they get their power from the host computer.

of lower capacity for these drives. While typical external hard drives range from about 300GB up to 1TB, bus-powered drives are typically limited to a range of about 40GB to 80GB.

Network Storage

If you have multiple computers, or the desire to add multiple computers to your setup, you can utilize those computers for your storage. This would most commonly be in an arrangement where a single computer functions as a "server" to provide central storage, but it can also include special devices that connect to the network used to transfer data among multiple computers to provide storage available to all computers on that network.

Server

The most basic form of network storage would be a server arrangement, where one of the computers connected to the network acts as a central storage point for your data. This doesn't have to be a cutting-edge computer tucked away in a closet somewhere, which is a common perception when the term server is used. Instead, it can be one of the computers on a network that is still used for other tasks, but which you designate as the primary storage location. That storage can be on the internal drive or on external drives connected to the designated computer. The data on those drives can then be shared among any of the computers on the network through the networking capabilities of your operating system.

While there is the potential to provide high-speed access to your images when connected through a network, and in many cases using this storage solution is simply a matter of utilizing the computer resources you already have available, there are some drawbacks to this method.

For one, most computers are somewhat limited when it comes to the amount of internal storage available. With typical configurations, you'd have difficulty achieving storage capacities of more than about 2TB. To many photographers that is a significant amount of data, perhaps more than would be needed over a period of several years. However, if you're utilizing a network for your imaging work, that implies that you probably have a staff of photographers or others working with the image, and therefore that your storage needs are significant.

Another is that the speed of the network can serve as a bottleneck for data transfer. In most cases, the speed at which data can be read from a local hard drive will be faster than the rate at which the data can move across the network.

In many situations, a network is utilized not because it provides a way to centralize storage (though that can be a considerable advantage) but because it provides a way for multiple users to access the same data. This is an appropriate reason for utilizing a network for storage, and for designating one computer on your network as the server where all images will be stored.

Network-Attached Storage

If you don't want to have another computer on the network that needs to be maintained just for the purpose of providing storage for your images, you might consider a network-attached storage (NAS) solution. This is a device that provides scalable storage with minimal need for management. You can think of it as being similar to an external hard drive that you can add to in order to expand its capacity, and that connects directly to the network rather than to another computer.

NAS represents an attractive solution because it is relatively easy to manage and can be expanded to meet your growing storage needs. The problem is that it has been, thus far, a very expensive solution. Even entry level NAS storage solutions start off at about $5,000, which isn't trivial considering you can buy an external hard drive with 1TB of storage for under $1,000. Still, with time the prices for NAS solutions will continue to drop, and it will become a more attractive solution for storing large volumes of data.

Network Performance

Whenever you're using a network for access to your images, it introduces a potential bottleneck because a network is able to operate at a fixed maximum data rate. Most networks in use today offer performance of 100 megabit per second (Mbps), which is about 11MB per second. This is considerably slower than the speed you'd achieve from an internal hard drive, as you can imagine. The actual data transfer rate is even slower because the network bandwidth is shared among users on the network, and other issues cause overhead that can slow things down further.

The next step above 100Mbps is Gigabit Ethernet, which offers the potential of one gigabit (or around 100MB) per second of data transfer. While this is still only a theoretical maximum, it does come very close to matching the performance you could expect from a typical hard drive. Therefore, when purchasing new computers, I strongly recommend including support for Gigabit Ethernet if you'll be utilizing a network in your workflow.

Of course, support in the computer isn't the only factor in network performance. You also need to have the appropriate network cabling to support the performance, as well as the right router (the box that serves as a traffic manager for the network, and which all computers will connect to on the network). Therefore, you may need to upgrade more than just your computer to take advantage of the fastest speeds possible. For any photographer who needs to transfer images across a network, Gigabit Ethernet represents a significant advantage, and I would most certainly recommend making the necessary upgrades to achieve the performance benefit.

Dealing with Big Files

As you start working to manage the images in your collection, you'll likely start to face some challenges with the largest of your files. There are many factors that can lead to particularly large image files, such as very high-resolution digital cameras, high-resolution film scans (especially of medium format film), composite images such as collages or panoramas, and images with a large number of image and/or adjustment layers. When files get large they become more difficult to manage because they require more storage space, more time to build thumbnails, more time to open or save, and more resources in general.

The first consideration for big files is the amount of space they'll consume. In Chapter 1 I reviewed some of the ways you can determine your storage capacity needs now and looking forward. Large files can skew your results, causing you to consume storage space much faster than you anticipated. As such, it is important to evaluate your workflow and consider whether you are frequently producing particularly large files. If so, you'll want to consider whether it might be

necessary to add additional storage space, increasing the estimates you made based on the review in Chapter 1.

The other issue is that these large files require considerably more processing power to open, view, and adjust. If you are using large files on a regular basis, it can be critical that you ensure your system is configured for optimal performance. That may require adding additional memory (RAM) so your computer can better handle the large files, upgrading to a faster storage solution such as an external hard drive connected via IEEE 1294b or a RAID-0 array for internal hard drives, or replacing your computer altogether with a faster model.

You may also be able to address some of the performance issues related to big files in your image viewing software. Many applications designed for viewing photographic images allow you to specify a limit on the largest files to be processed. For example, in the Bridge browser included with Photoshop you can adjust the preferences to limit the maximum file size for which thumbnails and previe,ws will be generated. The default limit is 200MB, but you can adjust this value as needed.

The bottom line is that big files require more resources to manage. If your workflow results in particularly big files (over about 100MB) on a regular basis, evaluate your overall hardware performance, software settings, and workflow practices to ensure you're minimizing the potential challenges of working with such large files.

Media Maintenance

I think of the media maintenance issue as something of the "dirty little secret" in digital imaging. While it is starting to be recognized as an issue, it seems that many photographers haven't given much thought to the fact that digital storage requires maintenance over time. With film you could simply file your slides away in a drawer and forget about them. As long as you took reasonable precautions to ensure the physical safety of the film, you could count on being able to make use of the images for decades to come. That isn't the case with digital images because of the rapid rate at which technology advances, and therefore the rapid rate at which many solutions become out of date.

Storage Media

This chapter has been all about the various solutions you can utilize for storing images. As you can probably already appreciate, there has been a remarkably rapid advancement in storage technology. As one example, within the last decade there were a number of point-and-shoot digital cameras that recorded directly to 3.5" floppy disks. Today, many computers ship without a 3.5" floppy drive, and it is getting more and more difficult to find such a drive. Within a few years this drive type could be virtually extinct. If you had a camera that recorded to 3.5" floppy disks and simply filed those disks away in a shoebox for archival storage, you could very soon find yourself in a situation where you have no way of reading the media.

Digital image files can quickly grow quite large, especially if they are composites of multiple images or contain many layers.

This ignores the fact, of course, that even if you had a drive capable of reading those 3.5" floppy disks, the disks may have deteriorated to the point that they are no longer readable.

There are two issues to address then. The first is the availability of a drive that can read the data you have written. In the case of removable media that means a drive that can read that media, while in the case of other solutions such as external hard drives that means a computer that is able to connect to and read from those devices. With time, storage solutions will evolve and in many cases the storage we're using today may be uncommon or impossible to find in a few years or more.

The other issue is reliability. While most digital media is very reliable, as with anything else they can deteriorate over time. Devices can fail, and media can be damaged by a wide variety of environmental factors.

The solution is to periodically validate the methods you are using to store your data, and confirm that you still have (and expect to continue to have for the near term) the ability to read and write to those media formats, and that the data on those devices can still be read reliably (with the understanding that you should still have a backup copy of all images, even if they are only being saved for archival purposes).

If either of these considerations is cause for concern at a given time, you should immediately work to transfer the data to newer or more reliable media. I recommend that you evaluate your storage solutions at least once a year to determine whether any maintenance is necessary to ensure ongoing access to your data.

File Formats

A similar issue is the longevity of digital image file formats. This is an area that tends to change at a much slower rate, but change does occur and it needs to be managed. Today we tend to utilize file formats such as JPEG, TIFF, and Photoshop PSD for most images. But with time those file formats may evolve, or be replaced by new formats offering specific advantages to the photographer, such as improved file compression with no loss of image quality, higher bit-depth support, or other benefits.

Over time we'll certainly see changes in the file formats being used, and as such it will be important to convert older files to new formats as change occurs. A good example of a situation where this could become a

problem is with RAW captures. With each new camera model it seems there is an updated version of the RAW files we use for this capture option, and there's no guarantee that software will exist indefinitely. For example, as older cameras fade away, software support for the RAW files captured by those cameras may similarly fade away. You don't want to end up in a situation where you have a large collection of RAW captures that you don't have any way of processing.

The point is that you need to maintain an awareness of what file formats you're using to store your images and the changes to those file formats or introductions of new formats. Whenever significant changes occur, it is important to evaluate your current image library and take action as necessary to ensure you'll still be able to read your image files reliably for the foreseeable future.

All Geared Up

Having created a plan for your storage needs and obtained the necessary hardware and media, you're ready to start thinking about how you actually store and manage your image library. In the next chapter we'll look at the basics of image storage before moving on to more advanced organizational considerations.

54
—
03

Chapter 3:
Storage Basics

At this point you should feel pretty comfortable with the overall concepts related to storage for your digital images. We can now turn our attention to the more practical aspects of dealing with your many image files, starting with the basics of storage.

Creating Structure

As you start saving your image files, and even as you download images from your digital camera, it is important to utilize some form of structure to ensure you are organized from the start. You can probably already appreciate how quickly digital images can accumulate. If you don't implement a storage plan, soon all those images are in complete disarray, scattered across many folders and perhaps across a variety of storage media. The most basic way to establish some organization is to create a structure for how you will save your image files.

It is important to keep in mind that there are as many approaches to staying organized as there are photographers, and no single solution is going to be ideal for all photographers. However, I think the principles of a basic organizational system make sense to all photographers. While you'll need to decide the specifics of how to organize your images, creating a basic folder structure and file naming convention that suits your needs and makes sense to you is an important first step in getting a handle on your growing library of images.

Folder Structure

There are countless examples of how digital tools utilize real-world analogies to help us understand what could otherwise be very complicated. The folder structure used for saving files is no exception. Papers are filed into a folder system in file drawers so you'll always (hopefully) be able to find a particular paper when you need it; similarly, computers organize files into folders. By using a well-planned folder structure to help stay organized, you can always find a particular image when you need it.

Of course, computers are able to take this analogy and extend it considerably, in large part because you can have folders within folders (often referred to as "nested" folders). By utilizing multiple levels of folders, you can create an excellent hierarchical folder structure that best meets your needs.

The first step is to decide on a structure that makes sense for your particular type of photography and your particular way of thinking about the images. The way I recommend assessing this is to consider what attributes of an image are most likely to come to mind when you're looking for a particular photo. For event photographers that might be the date the photo was taken. For nature photographers that might be the location or species photographed. For portrait photographers it may be the name of the subject being photographed. Consider what attribute is most important to you when trying to locate a particular image, and that will provide some guidance on the folder structure.

Any system you use should lend itself to multiple levels of folders in order to achieve a hierarchical structure. By using a hierarchy to define the image categories, you'll help to narrow down the number of images in a specific group. Let's say you only created folders for the year in which the photo was taken, you wouldn't be gaining any advantage when it came time to locate a specific image. You'd have to wade through all of the images for a given year in an attempt to find the one you're looking for. The more specific you can make your structure the better it will serve you in keeping a handle on a large number of images.

For example, if you are an event photographer, you might consider dates to be a critical factor in organizing images. You could create a folder for each year, and then within each year's folder you would put a folder for each month. If you do a tremendous amount of photography, you might even create daily or weekly folders within the monthly folders. Alternately, within each month's folder you might create folders for each event you photographed during that month. You could even take it a step further and create folders within the event folder to further organize images captured at the event, such as by breaking them into specific activities that occurred at the event.

As another example, if you photograph primarily landscapes, your folder structure may involve locations. You could then evaluate the range of locations you typically photograph, and create a structure accordingly. For example, if you photograph internationally, the top-level folders inside the Locations folder may be continents or countries. You could then create folders within each to get more specific about the location, as appropriate to the type and number of images likely to be in each folder. If you took a tour through Europe but moved relatively quickly and had only a handful of images from each city you stopped in, it might not be advantageous to create folders all the way down to the city level. Of course, if you make more trips to the same areas in the future, the library may grow, so it is important to maintain flexibility in your folder structure so you can easily make adjustments with time as necessary.

If dates are a primary consideration in your organizational system, you might create a folder structure that reflects the date for the photos contained within each folder.

Whenever possible, it is my preference to have all images (except for backup copies) stored in a single

location. So, for example, if your image library can be contained on a single large external hard drive, you might create a master "photos" folder on that drive, and put your organizational folder structure within that folder. If you need to span across multiple media for your primary image storage, I recommend trying to divide the image categories across the media. Try to balance the storage so you have plenty of space available for future growth. For example, if you have enough images to fill all of one external hard drive and a small part of the other, look for a way to logically divide the folders across the two drives to split the images evenly across them, while still maintaining a natural break in the folder structure. You don't want one category of images to be divided between two drives if you can avoid it.

Once you've decided on a folder structure that works for you and you have a sense of how the hierarchy will be defined, you can create a basic shell of that folder structure. I wouldn't recommend spending too much time creating many layers of folders representing categories you haven't even photographed yet. If you're a wildlife photographer, you obviously shouldn't create a folder structure representing every species of mammal known to man. Instead, start with the top-level folders to establish a basic structure, and create folders within those folders for the categories of images you have photographed the most. You can then move existing images into the appropriate folders, save new images to the same locations, and create new folders as your photo repertoire expands.

It can be very helpful to keep all of your digital image files, organized into sub-folders, in a primary "photos" folder.

The folder structure should be thought of as a dynamic system, changing with time as you photograph new subjects or decide you need to refine your system. It is therefore important that you evaluate the folder structure you're using from time to time to make sure it continues to meet your needs, and making changes as appropriate to improve the organization of your images.

A "New Captures" Folder

When you take new photos, you'll want to clear them off your memory cards and file them in the folder structure you've created. First, you'll want to delete images that don't meet your standards and rename images to make them easier to identify. Before you file new photos away into their specific folders, you should keep them all together so you can review them.

I recommend creating a high-level folder with a name such as "New Captures." Within this folder you may need to create folders for each photo shoot that was completed relatively recently. You can then sort through these images to delete those you don't want to keep and identify those that you want to optimize. After you've gone through this preliminary evaluation, you can move the individual images into the appropriate location in your folder structure.

File Naming Convention

A well-thought-out folder structure organizes the overall storage of your images and makes it relatively easy to find a specific image when you need it. As part of that system, you should consider the filenames you give your images to be an additional method for organizing your images, making it even easier to find the right image when you need it.

Filenames should be thought of as a continuation of the folder structure. To me, the greatest advantage to using a specific system for the filenames of your images is that it provides one more way to stay organized with a keyword search capability. Because you can easily perform searches on filenames, including looking for strings of characters within the full filename,

having names that are meaningful can make it much easier to find specific images when you need them.

As with the structure you identify for your folders, creating a system for file names requires you to consider how you think about your images, and how you're most likely to look for them. For example, if you are a portrait photographer you might want to incorporate the name of the model in the filename.

Fortunately, today's computer operating systems allow you to utilize rather long filenames, so there aren't any major restrictions. Some prior operating systems limited you to eight characters for the filename (plus a three-letter extension) to identify the file. Still, you don't want to go overboard with a filename that reads like a sentence describing the image. Instead, I recommend coming up with a file naming system that provides the minimum information you need to identify key information about the image. You'll also want to include a "serial number" at the end of the basic filename, so each file in a given category will have a unique name. Be sure to allow for enough numbers in this serial number to cover the

maximum number of images you expect to have in a given category.

As an example, if you're a portrait photographer, you might use a file naming structure such as LastnameFirstname4DigitSerialNumber .TIF. You could break this down to make it more legible by using a dash or underscore to separate the individual components. This is just one example, but if you find a system that helps you identify or locate a particular image, you'll have that much greater advantage in your organizational system.

An added advantage of a strong file naming system is that it will help you find and identify a particular image from its filename. For example, let's assume you send an image to a client for use in a project. The image is of a model in a red dress from a shoot during which the model changed outfits several times. The client calls you and tells you they want to see some photos from that same shoot of the same model wearing a different outfit. You review your records to figure out which photo you sent them. The file name is SJones-081405-RedDress018.TIF. From this you know that the model is Susan Jones, the

photo shoot occurred on August 14, 2005. In your organizational system, you have a folder for Susan Jones that contains folders with the date of each photo shoot you've done with her. You open the folder named 081405 and it contains 120 images. Each image filename includes the outfit worn in the photo, making it easy to pick photos that don't include the red dress. By using a file naming system that helps you identify the images, the filename gives you all the information you need to find the image and choose an alternate.

Photo by Chris Greene/www.imagewestphoto.com

Figure 3.3
Develop a file naming convention that allows you to determine key data about the image just by seeing the filename.

Preserving Original Filenames

In some cases, it can be important to preserve the original filenames your images had when they came out of the camera. This would be an issue if you ever need to return to the original file to start over with your optimization workflow. For example, if you capture in RAW you may discover some time later that a new software tool is available that provides a tremendous improvement in increased shadow detail and reduced noise for converted images. If you have some images that had been a particular problem, you may want to re-convert them with the new tool. However, if you've renamed the files to reflect the content of the images without preserving the original filename, it may be difficult or impossible to locate the original capture.

If you feel this could be an issue for you, I recommend retaining the original filename as part of the final naming structure you use. For example, the filename example provided above could be augmented to include the original filename, so the final result would be Lastname-Firstname-4DigitSerialNumber-OriginalFilename.TIF.

Saving Files

Once you've optimized your image, it is very important to save the file so you'll have access to it in the future. Of course, while we generally think of saving the file as the final step after optimizing the image, you should actually be saving the image at various points along the way in the process. My general rule is that you should save often enough that you don't have to re-do any more work than you want to. If you're lazy like me, you don't want to have to go back and re-do any of the adjustments you've made to your image. In that case, you'll want to be sure to re-save the image after virtually every step in your workflow.

When you save the file for the first time after making adjustments, you'll need to specify three important settings for that file: the location where it will be saved, the name the file will be saved under, and the file format it will be saved in. Once you have established all three settings, the file can be saved with confidence that you are maintaining some sense of organization even with the basic approach covered in the beginning of this chapter.

Location and Filename

By this time hopefully you've established a folder structure for saving your images (or are at least thinking about it so you'll be able to make a plan soon). The appropriate folder can then be identified based on the content of the image you're saving, and you can navigate to that location (or create a new folder as appropriate) when saving a new image.

Similarly, you should have a system for naming your files in mind so you can start implementing it for all new images you save. If you decide not to implement a file naming system, I recommend keeping the original filenames in place for your new master image files so they'll relate to the original capture filename. That way you'll always be able to connect the two, and if you aren't utilizing a file naming system that helps you organize your images, there's no real reason to use anything other than the filename provided by the camera.

Format

In Chapter One, I talked about the various file formats. However, now that we're getting down to the business of actually saving your images and getting them organized, it is worth recapping the choice of file format for the files that will result as part of your image optimization workflow. The files produced by your digital camera you'll automatically copy to your primary storage location, and you don't need to think about file format for those images after they've already been captured. However, when you get to the point in your workflow that you're saving your image files after optimization, you'll need to consider which file format to use.

The following file formats may be utilized for saving your images after processing:

Application Native Format—For most photographers, this would be a way of saying the "Photoshop PSD" file format. In general, whatever software you're using to optimize your images will have a native file format that enables you to save all the various elements

utilized by the special features of that software. For example, in Photoshop this could include multiple image layers, adjustment layers, layer masks, alpha channels, and more. In general, I recommend utilizing your application's native file format for saving your master image files. This will be the primary file you will save, and is arguably the most important file to save for a given image.

TIFF—This acronym stands for "Tagged Image File Format," and this has become a very popular format for saving image files, largely because it does not apply image compression (though that is an option with some applications). The result is a file that can be quite large, but that maintains the quality of your image. This is an excellent file format for versions of your image file that have been prepared for printing or that need to be sent to clients. In fact, some applications, including Photoshop, can save TIFF files with layers included, making them appropriate as a master image file format as well.

While the TIFF file format can be used to save layered files that include all the features supported by the Photoshop PSD file format, I still prefer to use PSD because TIFF is the format I use for flattened versions of images prepared for output. By making this distinction, I can see at a glance which files are my master images and which are copies for other purposes.

JPEG—This acronym stands for "Joint Photographic Experts Group," the name of the organization that created the standard. This is a lossy file format, which means quality is always degraded when you save files in JPEG. However, in some situations, such as when using images in a digital slideshow or on a website, you want to maintain a small file size. Therefore, this is a file format I would only use as a supplement to the master image, retaining these files when I feel it will save effort because I plan to use the same file in multiple presentations, for example.

Batch Renaming

With a system in place for organizing your files with a folder structure and utilizing appropriate filenames, you'll want to name new files and rename your existing images to fit the new system you've created. There are a variety of tools available for batch renaming a group of files automatically. I'll describe how this can be done with the Bridge browser that is included as part of Photoshop, but the same concepts can be applied using other software tools as well.

To get started, launch the Bridge browser and navigate to the folder containing the images you want to rename. If you want to rename all files in the folder there's no need to select them; by default the Batch Renaming tool in Bridge will rename all files in the current folder. If you only want to rename specific images, select them individually before continuing. You can select a series of images by clicking the first in the list and then holding the Shift key and clicking the last in the list. You can also individually toggle images as selected or not selected by holding the Ctrl/Cmd key and clicking.

The next step is to select Tools > Batch Rename from the menu in Bridge. This will bring up the Batch Rename dialog box, which provides a series of options to specify how the files should be renamed.

The first section is called Destination Folder, and it allows you to specify where you want to put the files. The default, "Rename in same folder", will cause the files to be renamed where they are. The new file names will replace the old file names. This is the behavior you want, if you have duplicate copies of the files backed up already. However, it does carry with it the risk that you'll rename the files in a way you didn't intend, and it can be difficult to recover from such an error. For example, if you rename a group of files so they no longer contain the original filename assigned by the camera, you'll likely never be able to figure out what the original filenames were. While this is the option I prefer to use, it is important to be very cautious when using it.

The other options in the Destination Folder are "Move to other folder" and "Copy to other folder". In the case of the "Move" option the files will be renamed and moved, making it not much different from the "Rename in same folder" option in terms of risk, with the only difference being that the

files are moved to a different location in the process. The "Copy" option will leave a set of files with the old name in the current folder, and then create a duplicate set with the new names in a different folder. In both cases you need to click the Browse button to identify which folder should be used for the move or copy operation.

The next section is New Filenames, which is the heart of the Batch Rename dialog box. This is where you're able to specify the structure of the new filenames you want to use for the images. You build that structure by identifying the pieces that together will create the final result. To start, select an option from the first dropdown. For example, if

Saving images in the TIFF file format maintains the quality of your image and is an excellent format for printing, whereas the JPEG file format compresses the image to achieve a smaller file size and is the standard format for website images.

you want to have custom text you would choose the Text dropdown, then type in the text in the box that will appear to the right. If you want to use a serial number, you would select Sequence Number, enter the starting value in the textbox that will appear to the right, and then indicate the number of digits using the dropdown menu to the right of that. You can add up to ten individual elements to the list by clicking the plus button to the far right, expanding the list of dropdowns. (The minus button removes dropdowns).

Let's take a look at a real-world example to give you a better idea of how this works. I'll use the same example of a model name discussed

The first step to batch renaming in Bridge is to navigate to the folder containing the files you want to rename. You can select individual files to rename. If you do not select any files, all files in the current folder will be renamed.

above, including a serial number and the original filename so the master image file includes a reference to the original source image. For this example we'll assume the model's name is Jennifer Hart, so a sample filename would be Hart-Jennifer-0001-IMG_0214.TIF.

Start by selecting the Text option from the first dropdown, and enter "Hart-Jennifer-" in the textbox to the right of that dropdown. If there isn't another dropdown on the next row, click the plus button to add one. In the dropdown on the second row, select Sequence Number. Assuming this is the first image for Jennifer Hart, enter the value 1 in the textbox. To ensure we have plenty of numbers available for photos of this model, select Four Digits from the last dropdown. Click the plus button to the right of this row if needed to add an additional row. From the dropdown on the third row, select Text and enter a dash in the textbox to the right. Click the plus button again if necessary for the next row. Finally, from the dropdown on fourth row, select Current Filename. In the dropdown to the right select "Name + Extension", and in the final dropdown select "Original Case".

The Batch Rename dialog box in Bridge allows you to specify a filename structure for the images to be renamed.

The Options section contains a couple settings that aren't generally a major issue. The first checkbox allows you to preserve the current filename in the XMP metadata, which is helpful as a safeguard for situations where you've renamed a file without preserving the original filename. The Compatibility section allows you to specify for which

operating systems the filenames should remain valid. The current operating system will be checked by default, and you can't turn this option off. If you want to ensure the filename structure you create will be compatible with other operating systems, you can check the boxes for those.

As you can see, at the bottom of the dialog box in the Preview section the original filename for the first file to be renamed is shown, along with a preview of what that file will be named based on your current settings. This provides an excellent opportunity for you to perform a "reality check" of the naming structure you've specified, making sure it is accurate and includes all the information necessary for you to utilize the filenames for your images to improve your organization.

Once you've provided all the details necessary and have confirmed the file naming structure at the bottom of the Batch Rename dialog box, you can click the Rename button to apply the changes to your images.

Strong Foundation

For many photographers, dealing with a computer to manage their photographic images is anything but natural. This chapter has provided you with a strong foundation in the basics of storing and managing your files. At this point you should be feeling much more comfortable with the issues related to managing your images at a basic level, ready to move on to more advanced topics.

Chapter 4:

Image Browsers

At this point you are starting to get organized in the storage of your images, but we haven't dealt with how to actually review your images and find the right one. In this chapter I'll take a look at some of the available options for basic image browsing. These are programs you can use to view the images in both thumbnail and larger preview sizes. You can evaluate images, discard those that aren't up to your standards, categorize them, rename and add keywords for easier searching, identify your favorites so you can optimize them to perfection, and in some cases use very basic image processing tools.

Role of the Browser

Even if you plan to use a full-featured image management application (and I'll cover some of your options in Chapter 5), a basic image browser can be very helpful for quick reviews of your images. When all you want to do is take a look at the images contained in a specific folder, for example, a browser is the right choice.

For some photographers, a basic image browser is the only management tool necessary when used in conjunction with a well-organized folder structure and file naming system. When you know exactly what folder to go to in order to find the right image, the only other tool you need is software that allows you to quickly and easily see the images in that folder so you can find the image you're looking for or review all of the available images to decide which is most appropriate for your current need.

Because most image browsers provide very little (or even nothing) in the way of full image management, it is important to recognize that they won't necessarily help you stay organized. Think of them as a virtual light table allowing you to view your slides. With a real-world light table you still need to know where to find the slides you're looking for. Similarly, image browsers won't generally do much to help you find specific images you're looking for. That may make them sound like they're not very helpful, but the opposite is actually true. They can be invaluable in helping you navigate through the many images you have accumulated.

Of course, with many file types you can view images directly in your operating system, which might make a separate image browser seem superfluous. However, most of these applications offer faster image viewing than the operating system, and all of them offer features above and beyond what you'll find built in.

For many photographers, an image browser provides the necessary image management features required to find the right image when you need it. If you have created a folder system that allows you to categorize images based on the way you typically need to look for them, and perhaps utilize a file naming system to help when you need to search for a particular image, an image browser serves as the viewer in your overall image management system. Of course, as I'll discuss in Chapter 5, if you want to take things a step further there are a variety of image management applications to choose from, but an image browser used in conjunction with a good folder structure can serve as a good, basic image management solution.

Browser Options

There are so many image browsers available I could probably write an entire book just talking about all the features of the many applications available. However, because there is so much similarity between them in terms of the core feature set, doing so would

not be particularly helpful. Instead, I'd like to highlight some of the most popular image browsers, including some I've found helpful, to give you an idea of a few of the many options available. A free trial version of some of these applications can be downloaded, so you can test these (and others) to find the one that best meets your needs.

Here are some of the more popular image browsers currently available:

ACDSee (Windows only) from ACD Systems (www.acdsystems.com) provides surprisingly fast image previews, support for RAW capture formats, and basic organizational tools in the way of ratings and the ability to assign categories. It also allows you to batch process or individually correct images for quick fixes, build slideshows to share with others, and share photos through ACD Systems' free online image sharing service.

CompuPic Pro (Windows only) from Photodex (www.photodex.com) claims to be the fastest at generating thumbnails, but in my experience it isn't particularly quick. It also doesn't

allow you to view RAW captures. Despite these limitations it is still a good basic image browser, providing all the key features you need for reviewing your images, basic image adjustment tools and great sharing features such as emailing of images, quick web gallery creation, and building digital slideshows.

iPhoto (Macintosh only) from Apple (www.apple.com) is part of the iLife suite of media management software. It has a wide array of features to help you organize, edit, and share images. You can assign keywords, customize categories for sorting images, and import photos, including RAW capture formats, directly from a digital camera. Order prints with the click of a button, provided you've set up an account. There's also a feature that let's you arrange your photos into a book. One drawback is that you must be a .Mac subscriber to email images or create a web page with iPhoto.

Photo Explorer (Windows and Macintosh) from Ulead (www.ulead.com) is a relatively basic image browser that focuses on simplicity and speed. It does not have as many of the bells and whistles of other applications. It does include the basics such as the ability to create basic slideshows or email photos, as well as some simple quick-fix corrections for your photos. The biggest omission is that Photo Explorer does not allow you to view RAW captures.

These are just a few of the many options available for browsing your images, but they are among the most popular. If you're looking for a new image browser application, download the free trials available here, but also check other resources such as websites dedicated to digital photography, referrals from other photographers you know, and magazine reviews to discover other image browsers that might meet your needs. Every photographer has a different perspective on the features they need when browsing their images, so you'll find many different opinions. Find the application that fits best into your workflow and you'll be better able to manage your digital images.

Adobe Bridge

Because most photographers are using Adobe Photoshop to optimize their images, I'll provide an in-depth look at the Bridge browser first included with Photoshop CS2. This is a good basic browser that provides some rating and labeling features to help you manage your digital images. Seeing how Bridge works will give you some insight into how to use just about any image browser since the fundamental features are very similar across all applications in this category.

Adobe Bridge is the update to the File Browser supplied with previous versions of Photoshop. It is now a stand-alone application, which can be very convenient when you simply want to browse your images without necessarily launching Photoshop in order to do so. For basic image browsing and management, Bridge can be a very helpful tool. Because it is integrated with Photoshop, it also provides access to some excellent automation tasks, such as the ability to apply Photoshop actions to a group of images quickly and easily.

Since most photographers these days are using Photoshop to optimize their images, Bridge serves as an excellent example to introduce you to the concepts related to image browsers. I'll therefore take you through the process of how I configure and utilize Bridge to help you understand the general concepts you might use with any image browser application, and to enable you to make the most of Bridge if you decide to use it as your primary image browser.

Configuring Bridge

The first step is to configure Bridge to best meet your needs. I'm of the opinion that the default configuration for Bridge isn't very useful. For example, the Preview palette offers an image that isn't much bigger than the thumbnail view and the Metadata palette consumes a considerable amount of space on the display even though most photographers use it only occasionally. Launch the Bridge browser, either using the shortcut for this application directly or by clicking the "Go to Bridge" button on the Options bar in Photoshop, just to the left of the Palette Well.

If you have already configured Bridge with a custom workspace, you may want to save that workspace by selecting Window > Workspace > Save Workspace from the menu, entering a name, and clicking Save.

To make sure you're starting from the same view, reset the Bridge workspace to the default by selecting Window > Workspace > Reset to Default Workspace from the menu in Bridge. This will give you the standard configuration with the left side divided into three palette areas and a relatively large area on the right for viewing thumbnails.

We'll start by cleaning up the Bridge workspace to make better use of the available display area. My preference is to drag all of the palettes into a single area to provide more space for the particular palette I'm interested in at a given time. Point your mouse at the Preview palette's tab, and drag it up toward the area where the Favorites and Folders palettes are. You'll see a blue box appear around those palettes to indicate that when you release the mouse the palette you're dragging will appear in that area. When you have that box visible, release the mouse and the Preview palette will appear up with the Favorites and Folders palettes. Bridge will then automatically collapse the area where the Preview palette was since there aren't any other palettes in that area.

Do the same thing to move the Metadata and Keywords palettes up into the same area, resulting in a single location for all the palettes. This will consume the full available height on the left portion of the display.

Click on the Folders palette and choose a folder that contains some images. The thumbnails will appear on the right side. However, depending on your display resolution you may want to resize the thumbnails. I prefer to work with moderately small thumbnails so I can see more images at one time, referring to the Preview palette in order to evaluate the image more closely. At the bottom of the Bridge window near the right side is a slider that allows you to dynamically change the thumbnail display size. Moving the slider to the left will reduce the size of the thumbnails and sliding to the right will increase their size.

Lightbox View

Once you've configured the Bridge window, you're ready to start reviewing the images in the current folder. I usually prefer to get an overview of the images first, deleting those that are obviously bad while getting a general sense of what images I've captured and which might be my favorites.

When performing this review, I want to see as many of the images as

The default configuration for Bridge isn't very efficient in terms of use of screen real estate or usability.

possible at one time to make the process more efficient. I think of this as being very similar to the way I would review slides back when I would still capture with film. I'd lay sheets of slides on a lightbox and get an overall view of the images. Those that were obviously bad exposures, out of focus, or had other problems significant enough to see without examining the images too closely would be tossed at this point. I'd also start to think about which images had the potential to be favorites I'd want to scan into the computer and optimize.

With an image browser, you can perform this same type of review with your digital images. To create such a lightbox view of digital photos, I slide the vertical bar that divides the Bridge window between the palettes and thumbnails all the way over to the left. This hides the

palettes and provides the maximum amount of space possible for the thumbnail images. I can then scroll through the list of thumbnails, deleting images I don't want, and evaluating images to determine which ones will be the favorites.

Preview View

Once I've performed a general overview of the images using the lightbox view, I want to start getting a closer look at the images to make sure they are really of the highest quality (and that I like them aesthetically). The first step is to enlarge the palette area, so drag the vertical bar that

Moving all the palettes into a single area on the left side of the Bridge window will allow you to make better use of the available space.

is now at the far left of the display, moving it over to the right leaving just enough space for one column of thumbnails.

Next you'll want to click on the Preview palette so you can actually see the large preview image for the current image, so click on the tab for the Preview palette. Then scroll up and click on the first image in the current folder. This will display the preview for that image in the Preview palette area on the left. You can then use the up and down arrow keys on your keyboard to move through the images one by one, viewing a larger preview. You may find that some of the images you thought were perfectly fine from looking at the thumbnail are in fact not very sharp or have other quality issues once you're able to view a larger preview. Therefore, I think of this as a more detailed second pass over the images, making decisions about which images to keep with stricter criteria. This is also a good time to start identifying which images are your ' favorites, as those are the ones you'll likely want to spend most of your optimization efforts on.

Rating and Labeling

As you go through your images, especially after you've removed those that don't meet your standards, you'll want to start identifying which images are the best from a particular photo shoot. There are a variety of ways to do this. You could, for example, move your favorites to a separate folder for each shoot. However, since most image browser applications allow you to mark your images in some way, I prefer to take advantage of that feature so I can keep all related images together.

In Bridge, the rating feature can be very helpful in identifying the images with a star rating you can use to indicate in relative terms which images are your favorite. Bridge uses a system of one to five stars (or no rating at all) to identify the images. From the Label menu in Bridge you can select No Rating or a one star through five star rating. Much like similar ratings you've probably seen for movies, five stars represents the best and one star the worst, with No Rating generally implying you simply haven't evaluated the image yet.

Besides using the menu, you can also use the mouse to apply a rating to your images. When you select a thumbnail on the right side of the

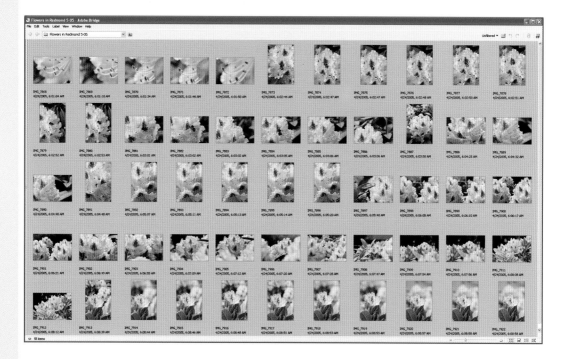

By sliding the vertical bar to the far left in Bridge, you can get a view of a large number of images at once—similar to the view you would get if you spread out slides on a lightbox.

Bridge display, you'll see five small dots below the image. This is an indicator of the rating, and with five dots it means no rating has been assigned. You can click on one of the dots to apply a star rating to the image, with the leftmost dot representing one star and the rightmost dot representing five stars. Simply click to assign the desired star rating. Once a star rating is assigned, you can click to the left of the first star to change the rating to "No Rating".

You can also use keyboard shortcuts to assign ratings in Bridge. With an image (or multiple images) selected hold the Ctrl/Command key and press 1 for one star, 2 for two stars, and so on. You can hold Ctrl/Command and press 0 to apply no rating.

Once you've applied ratings to your favorite images, you'll be able to sort them based on the ratings you've applied. This allows you to review the ratings you applied in context with similarly rated images and also to see all of the best images together. To sort the images based on their rating, choose View > Sort > By Rating from the menu in Bridge. I usually find that I want to have the highest-rated images at the top of the list, so I also turn off the default option to have the images sorted in ascending order by selecting View > Sort > Ascending Order (when there is a checkmark to the left of this item on the menu it means images are being sorted in ascending order based on the attribute you're currently sorting by).

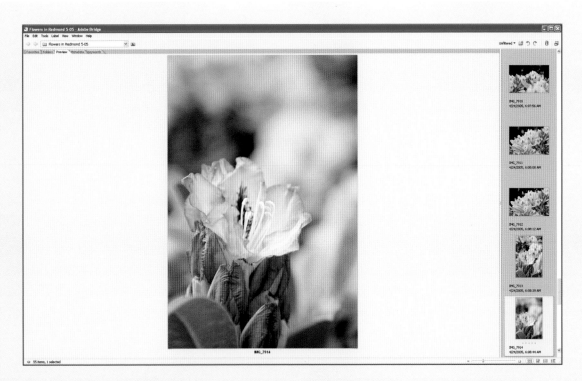

By sliding the vertical bar to the right, leaving just enough room for one column of images, you can review the photos with a large preview image.1

Bridge also offers an option to label your images, which allows you to further identify specific images beyond just rating them. Bridge uses a color-coding system for labels, with the available options being red, yellow, green, blue, purple, or, of course, no label at all. Labeling works in a manner similar to rating, except that you can't just click an option on the thumbnail to assign a label. You can, however, right-click and choose Label and then the desired color from the context menu that pops up.

You can also assign labels by choosing the desired color from the menu. For example, Label > Red will assign a red label to the currently selected image. When a rating is applied, it appears as a colored bar where the star rating is displayed below the thumbnail of the image. You can also hold the Ctrl/Cmd key to assign a label, pressing 6 for red, 7 for yellow, 8 for green, and 9 for blue. There is no shortcut key for purple or for removing the label (but you can remove a label by selecting Label > No Label from the menu).

If you find the colors themselves aren't meaningful enough to you it is possible to change the text associated with the color labels. This won't change the appearance of the color label itself, but provides a way to remember the meanings you've applied to each of the colors. For example, you might decide that a red label means the image should be submitted to your stock agency, and a yellow label means the image should be printed for display in your gallery. If you don't remember those meanings, the system won't work very well.

You can assign new names for the colors by selecting Edit > Preferences from the menu in Bridge. Select Labels from the left side of the Preferences dialog box, and then enter new names as desired for each of the color labels. You can then go to the Preferences dialog box to remind yourself of the meaning, or even just look at the Label menu as the color names will now be replaced with the text you type (the only challenge with viewing it on the menu is that you won't be able to see which color label is associated with the specific text label you've assigned).

Slideshow View

Another great way to apply ratings and labels to images in a relatively automated way is to use a slideshow

CRW_7314
10/23/2004, 2:09:24 PM

Adobe Bridge allows you to use a star rating system to rank your images, ranging from one to five stars, with five stars representing your best images.

view in Bridge. This is a simple yet surprisingly effective way to review your images and apply ratings to them.

While you are viewing a folder of images, you can select View > Slideshow from the menu or hold the Ctrl/Cmd key and press the L key. This will put you into slideshow view, with the image nearly filling the screen. A gray background will be displayed around the image to help avoid color clashing. By default the keyboard shortcuts will be displayed in a translucent window over the slideshow. You can hide this display (or reveal it again) by pressing the H key.

The slideshow can be paused and resumed by pressing the Spacebar. Once the slideshow is active, the images will cycle on the screen. If you have selected images in Bridge, only

those images will be displayed. Otherwise the entire contents of the current folder will be included in the slideshow. When the last image is reached the slideshow will end, but you can have it loop repeatedly by pressing L. As the images are displayed, you can assign a rating by simply pressing the numbers 1 through 5 (no need to hold the Ctrl/Cmd key when in slideshow view). Pressing 0 will revert to no rating for the current image. Labels can be set with the numbers 6 through 9, again without the need to hold the Ctrl/Cmd key.

Performance Limitations

I don't think it's any secret that Bridge isn't the fastest application when it comes to image browsing. In fact, when building thumbnails and previews for a

large number of images it can be painfully slow. However, it offers a great set of basic features and is integrated well with Photoshop, so I still find it to be a great solution for my image browsing needs. I just don't like dealing with the slow performance.

However, Bridge only needs to build thumbnails and previews once, and then is able to display them very quickly. Slow performance is only an issue the first time you point Bridge to a folder full of images. When you revisit a folder after the images have been processed, the thumbnails and previews display very quickly. Bridge stores the thumbnails and previews once they are generated. In the future when you view a folder that has already been processed the performance will be fast.

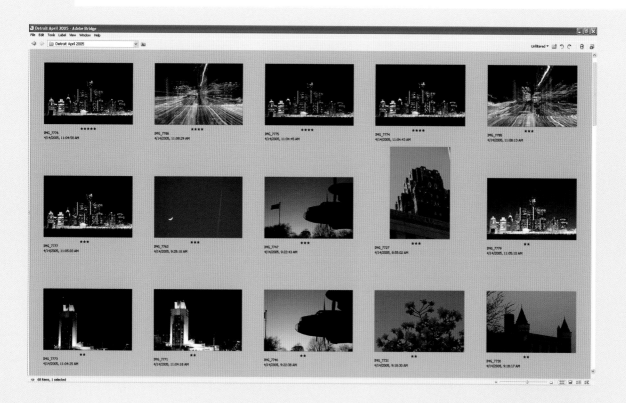

The first step to batch renaming in Bridge is to navigate to the folder containing the files you want to rename. You can select individual files to rename. If you do not select any files, all files in the current folder will be renamed.

IMG_8408
6/20/2005, 6:58:46 AM

You can label images by color in Adobe Bridge to help categorization for your images.

The solution: don't sit at the computer waiting for Bridge build the thumbnails and previews.

I recommend when you download images and move them into a particular folder that you open Bridge, point it to that folder, and walk away. Give the program an adequate amount of time to build all thumbnails and previews for that folder. Don't try to browse your images until the process is complete. If you do, you'll probably discover that you're able to scan through the images at a faster rate than Bridge is able to build the thumbnails and previews. This can be frustrating when you catch up and have to wait. While Bridge is processing the images you'll see a message to that effect in the bottom-left corner of the window. When it is finished, that same area will indicate how many images are in the current folder.

For images you have already captured, there is one thing you can do to improve on the slow performance of Bridge or at least concentrate all the time required into a single period for a large number of images. To do this, point Bridge at the primary folder where you have your images stored and select Tools > Cache > Build Cache for Subfolders. Bridge will then build thumbnails and previews for all images in all folders within that primary folder. The process will require considerable time, but once it is done, you won't have to wait for those images to be generated again in the future.

Seeing Clearly

A basic image browser is a great solution in conjunction with a folder and file naming structure to provide a basic way to keep your images organized. This provides an inexpensive way to get started with a basic system, and with proper planning can help ensure that you're always able to find the right photo when you need it. In the next chapter I'll take this a step further with image management software that enables you to get even more organized.

Slideshow view in Adobe Bridge provides an excellent way to apply ratings and labels to a large group of images with ease.

Chapter 5:

Image Management Software

At this point you've learned about basic image browsing using a variety of solutions. In this chapter I'll go beyond basic browsing and cover image management software. These solutions are generally more feature-rich. In addition to browsing, you can catalog your images, search for particular files, and view/edit keywords and metadata. Also, most have image manipulation functionality.

Role of Image Management Software

With the digital camera revolution, photographers are shooting more photos than ever. Even after reviewing and deleting poor images from a shoot, a photographer is often left with a large number of 'keeper' images to manage and store.

For some photographers, a basic image browser is the only management tool necessary when used in conjunction with the folder structure and file naming system I covered in Chapters 3 and 4. However, an image management solution allows a photographer to categorize their images in a way that will make it easier for you to find a specific image, or set of images, without having to remember exactly what folder you stored them in.

In my workflow, Image Management tools are used to catalog my 'keeper' images, as they are the ones that I always have to refer to down the line. This is why I tend to use both image browsing and image management software. This allows me to use one to sort through a large volume of images, and the other to review only specific, high quality images.

Image Management Options

There are many options available to you in the category of image management software. There isn't one dominant player in the image management segment like Photoshop is to the editing space, but I will be primarily focusing on Extensis Portfolio, and iView Media Pro. I will be covering the basics to help you make the choice that best suits your needs and get you started using these applications.

Extensis Portfolio

Portfolio 7 from Extensis offers both a standalone client and server-based product for those who have multiple computers in a network needing to share access to files on one or multiple drives. With the server product, you can assign specific access to catalogs for various job functions, and once configured, users on both PCs and Macs can access the files as if they were local to their machine. I will be focusing on the standalone interface, as it is where the majority of the user functionality resides.

One of the nice things about Portfolio is that it only stores thumbnails of your images in its catalogs to improve speed. A pointer to your original image is stored within the catalog so that you can still preview, edit, and more right from Portfolio.

Getting Started with Portfolio

When you open Portfolio, the first thing you are presented with is an option to either create a new Portfolio catalog or open an existing catalog. Obviously, if this is your first time opening the application, you'll want to select the

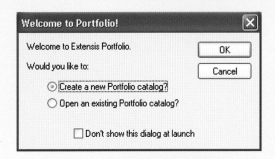

When first getting started in Portfolio, you'll need to create a new catalog.

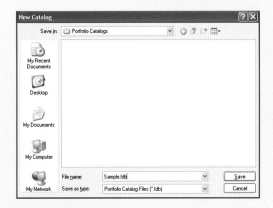

When creating a new catalog, you need to specify a location in the New Catalog dialog box.

option to create a new catalog. If this is the option you select, once you click OK, you will be prompted to choose a location to store your catalog, and you will also give your catalog file a name.

To re-enable this, select Edit > Preferences. On the General tab, enable the Show Welcome Dialog at Startup checkbox. While you are getting used to the application, and configuring the software to suit your needs, this option

can be helpful when starting up Portfolio. Once you have everything working the way you want it to, I recommend setting the option to "Open an Existing Portfolio Catalog" and then enabling the checkbox for "Don't Show This Dialog Box at Launch".

Once you have created or opened a catalog, the first thing you will need to do is add images to the catalog so that Portfolio can create the previews and track the images. There are a few ways you can add images to your catalog:

Within Portfolio, you can click on the Add button in the toolbar, which will bring up the Windows folder browser. Simply navigate to the folder containing your images, select the specific image(s) you want cataloged, and click Open.

Within Windows Explorer, navigate to the folder containing the images you want cataloged. Select the images you want to add to Portfolio. Right-click on them, select Add to Portfolio, and then click on the catalog that you want the images added to.

Within Windows Explorer, navigate to the folder containing the images you want cataloged. Select the images you want to add to Portfolio and then drag and drop them right in to Portfolio.

After you've added images to your new catalog, you will be presented with a Cataloging Options dialog box. Here you have the option of batch editing your files to help make your workflow more efficient. There are three primary functions available: Assign Properties, Copy or Move files to a Location, and Rename Files. Also, there's an Advanced button at the bottom of the dialog box that displays additional options.

Metadata

I wanted to take a minute to discuss metadata more—what it is and what it can be used for. Metadata is simply data about data. The concept of metadata has been around for a long time and it isn't specific to imaging, but applies to any type of digital file. Things like copyright, author, focal length, and

Clicking the Add button is an easy way to access images to be added to your catalog in Portfolio.

applied keywords are all examples of metadata that can be used to describe a file. The following are the primary types of metadata used on digital image files:

EXIF—EXIF data is information related to the settings of the camera when the image was captured. Details such as camera model, lens, focal length, aperture, and shutter speed are all included in the EXIF data and can be helpful to a photographer when trying to understand more about an image. I often refer to the EXIF data when I am trying to identify a mistake I may have made capturing an image.

IPTC—This is data that can be manually added to better describe an image. Examples of IPTC data are description, creator, keywords, and title. This type of information can take time to add, but it is extremely useful in providing details about an image and may dramatically cut down the time it takes to locate a file later. IPTC data is commonly used in photojournalism and stock photography. I typically try to add as much IPTC data as possible when I am downloading my images.

XMP—XMP, created by Adobe, is a recent addition to the metadata world. XMP stands for Extensible Metadata Platform and is a means of grouping metadata together to make workflow more efficient. The two most common places where XMP is used today are in Adobe applications. If you are using Photoshop, for example, and select File Info from the File menu, you are viewing the XMP data about that image. EXIF and IPTC data for the file are located within the XMP File Info. Another application that uses XMP data is the Adobe Camera RAW utility. When you make changes to a RAW file, those changes aren't actually written to the original file. Instead, a Sidecar file is created containing XMP metadata with the settings and changes you made to the RAW file. This way, when you open that RAW file next time, the changes appear, but the actual image file is unaltered.

Assign Properties—This option allows you to add information such as a description of the images, keywords, and metadata. This is something that I encourage everyone to use. Applying keywords and metadata makes it easier to find your images when you need them, and this data can also be helpful

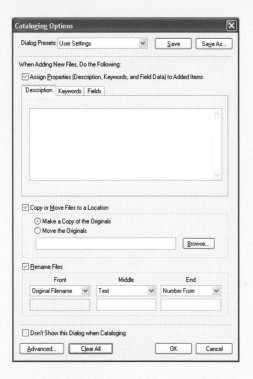

The Cataloging Options dialog box provides you with a variety of functions related to the images being added to the catalog.

originals. Use the move function if you prefer to store your processed or 'keeper' images in a separate directory.

Rename Files—If you are copying or moving your keepers to another location, you may wish to perform some renaming of these images so that you can identify them as final or cataloged, for example. You have the option to add or modify the front, middle, and end of the file name. You can choose to utilize the existing filename in any one of these fields and you can also enter text or add sequential numbering.

Advanced—At the bottom of the Cataloging Options dialog box is the Advanced button which displays an additional set of options. Here you can configure settings, such as thumbnail size/appearance and the types of files that Portfolio will catalog. For me, one of the most useful settings is on the Properties tab where you can set Portfolio to create keywords based on the volume, path, folder, and file name. If you have a well thought out storage hierarchy and file naming plan, having Portfolio add these pieces of information as keywords can be very helpful later when you need to find your images.

if you sell your images or submit them to competitions because you may be required to supply camera settings, subject information, and other data.

Copy or Move Files to a Location— Here you can make a backup copy of your images in another location or just move images to a new folder. If you use copy the feature, it is one way of ensuring that you have a backup of your image files. I always recommend that the backup copy be stored on a separate physical drive from the

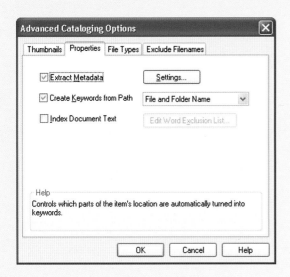

The Advanced Cataloging Options dialog box provides additional settings related to the handling of your images in the Portfolio catalog.

Once you have setup the cataloging options, you can save the presets. It's a good idea if you know you are going to use these same settings again. When you need to add more files to a catalog, you simply select the appropriate preset from the Dialog Presets dropdown menu. To save your presets, click the Save As button at the top of the Cataloging Options dialog box and enter an appropriate name that represents the options you are saving. I have several different presets depending on the type of images I am cataloging and what the output

The Dialog Presets dropdown allows you to select from a list of saved presets to make future additions to your catalog easier to manage.

may be. Once you've set the Cataloging Options and saved the presets (if desired), click OK and Portfolio will begin the process of cataloging the files that you selected.

Background Cataloging

Portfolio provides an option to automatically check folders for new files and catalog them at an interval that you determine. I personally have this process run once per day as I don't need to access the files in my catalog instantly, but your needs may vary. This feature is called Background Cataloging, and is an extremely useful function, especially if you store images that you plan to catalog in a designated folder or folders. When new files are cataloged using this feature, these new files will have the same information applied that you have configured in the Cataloging Options dialog box that I detailed above. In addition, depending on your workflow, you have the ability to create multiple background cataloging configurations. I find this feature very helpful as I don't have to think about manually adding finished files to my catalog. I simply drop these files in to my catalog directory on my machine, and the background cataloging takes care of the rest.

To set this option, select Background Cataloging from the Catalog menu. You are presented with a blank dialog box. You must click the New button to configure a new background cataloging set. In the Configure Background Cataloging dialog box, you need to provide a name and then select the folder path for the automation to monitor. Note that you can select a top-level folder and then enable the checkbox to include nested folders. From here, you can select the interval that you'd like the process to run on. As I mentioned, I run mine on a daily basis, but if you want faster access to your files in the catalog, you will want to opt for a shorter interval. The other option you will need to select is whether or not you want the cataloging status window to be displayed as the background processing is run. If you are running the background cataloging during the day while you may be doing other work in Portfolio, I recommend that you hide the status window so that you can continue to do your other work.

Configure Background Cataloging

Name: Wedding Image Drop Folder

Folder to watch:

D:\Images\Wedding\Drop Browse...

☑ Include nested folders

Check folder for changes every:

1 day

When synchronizing the catalog with the folder:

◉ Hide the Cataloging Status window

○ Display the Cataloging Status window

☐ Use cataloging options preset

Available presets contain move operations and/or assigning properties.

OK Cancel

The Configure Background Cataloging dialog box allows you to set the parameters for a background catalog.

FolderSync

While Background Cataloging is a convenient way to automatically catalog new image files, it is only a one-way automation utility. If you plan to perform a number of changes to your files once they are cataloged in Portfolio, you may want to have those changes applied to the original file as well as having the information changed in the catalog. The process of updating the original files can be automatically done via the FolderSync option. This is a very powerful utility as you can now manage your image files and folders directly from Portfolio rather than having to switch to your operating system's file manager.

While FolderSync is a very useful and powerful tool, you must use caution when synchronizing images and folders. Given that the synchronization is a two-way operation, you will be editing your original files and folders rather than just adding data to your catalog.

In order to start using FolderSync, you need to choose a folder for Portfolio to watch. If you add a folder that has sub-folders nested within, Portfolio will watch the entire hierarchy. Within the Folders pane, click the Add Watch Folder button. The Browse for Folder dialog box will appear, and you can then select a specific folder or several folders to

The Folders pane includes the ability to add a watch folder that will be monitored by Portfolio.

Once you have synchronized folders, you can click on an individual folder to view the contents.

watch. Note that you can also create a new folder to synchronize if you don't already have something established. Once you click OK you will see the folder or folders to be synchronized listed in the Folders pane. To begin the synchronization process, simply select the folders in the Folders pane and click the Synchronize button.

Organizing Your Files in Portfolio

Now that you have a set of images entered into your catalog, you are ready to customize and organize your catalog data. I will discuss how to get the most out of Portfolio by showing you some of the key features around organizing your files. Portfolio gives you a number of utilities that are designed to help you find your images when you need them as well as be more detailed in your image management.

Galleries

The first thing that I do once I've pulled my files into a catalog is to organize my images into galleries. Galleries are basically categorized subsets of your entire catalog. They can be used to group images in ways that mean something to you, such as by subject, date, or client. You can see and access your galleries via the Galleries pane on the left side of the screen. By default, there are three preset galleries: All Items displays all images in the catalog; Last Cataloged displays only those images that were brought into the catalog during the last import; and Search Results displays the images compiled in the most recent search.

When you select the All Items option in the Galleries, all images in the current catalog will be displayed.
Photos by Mike Tedesco/www.tedescophotography.com

You can create new galleries by clicking the + button within the Galleries pane. At this point you need to give the gallery a name. It should be indicative of the images that will be added. Once you've created your gallery, you can select the images you want associated with that gallery from the All Items gallery. Then, just drag and drop the images onto the gallery name in the Galleries pane. Once you're finished adding images to a gallery, click on it in the Galleries pane and you will see only those images associated with that gallery. Images can be associated with more than one gallery.

When you have added images to a specific gallery and then click on it, only the images included in that gallery will be displayed, as with the Sports gallery shown here.
Photos by Mike Tedesco/www.tedescophotography.com

Keywords

Keywords are a very effective piece of metadata that can be used to find specific images when you need them. I try to use many keywords to describe each image so that I have a better chance of locating one when I need it. For example, if I have a photograph of Mt. McKinley taken in winter, I would add keywords such as: Alaska, Denali National Park, United States, mountain, snow, winter, cold, nature, and landscape. Depending on what you use your images for, you may want to even add keywords for attributes, such as shapes, colors, time of day, moods evoked by the photo, and other meaningful identifiers.

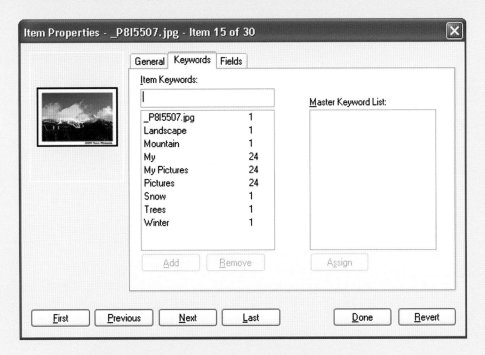

Choosing appropriate keywords for your images in the Portfolio catalog can be critical to being able to find the right image later.
Photo by Mike Tedesco/www.tedescophotography.com

The following are a few other ways to apply keywords within Portfolio:

Edit Keywords dialog box—If you need to add the same keywords to a number of images in your catalog, you can select all of the images and then go to Item > Edit Keywords. Here you can enter a keyword and click the Add button to apply the keyword to all the selected images.

Item View—One of the different views available in Portfolio is Item View, which shows a thumbnail of the image along with specific information about that file. This information includes the keywords that are applied to that image. You can simply click on the keywords field and type in additional keywords for an image.

The Edit Keywords dialog box allows you to add keywords to an image or images in Portfolio.

Drag and drop—If you have a list of keywords stored in some type of document such as Microsoft Word or Excel, you can highlight the keywords within that document and actually drag and drop that text onto an image in Portfolio. Those words will be added to the keywords list for that image.

As you can see, there is a lot of flexibility in the way you can apply keywords to images within Portfolio. The key is finding which method integrates best into your existing workflow.

I've covered a lot of information about keywords as I feel this metadata is critical in describing and later finding your images. I can't emphasize enough the importance of a detailed and effective keyword plan. As I noted earlier, think about what you plan to do with your images, and apply any details that you think will be helpful down the line.

Finding and Accessing Images

Obviously, a critical aspect of any image management software is the ability to quickly find and access the images in your catalog and/or file system. Portfolio has a number of utilities that will help you access the files you need. While I don't cover every possible way to find your images, I will cover the utilities that I find most efficient and effective in finding your files.

QuickFind

Located on the right side of the toolbar, you will see the QuickFind search box. This feature, by default, searches the filename and the description fields using a 'contains' search. You can also add fields for QuickFind to search against, by selecting, Edit > Preferences, and then clicking on the QuickFind tab. Here you can enable checkboxes on specific metadata you want included in your searches. To perform a QuickFind, simply click in the QuickFind search box, enter the words you are looking for, and either press the Enter key on your keyboard or click the QuickFind

The QuickFind tab in the Preferences dialog box enables you to select the metadata fields you want to incorporate in your search.

button. The results will be displayed in the Find Results gallery. Note that QuickFind only searches within the selected gallery. If you want to search through all your cataloged images, be sure the All Items gallery is selected.

With QuickFind, you also have the ability to do multiple searches. For example, if I need to locate a flower of a specific color, I would select the All Items gallery and enter the word 'flower' in the QuickFind. Once all of the flower images are in the Search Results gallery, I would then enter the specific color (e.g. yellow) in the QuickFind field and apply the search to this gallery. The result would be that images in the Search Results gallery would contain yellow flowers. Remember that a search is only useful if the appropriate keywords exist in the filename or the image metadata.

Searching from Palettes

Within any palette in Portfolio you can double-click on an entry and Portfolio will perform a search based on that item. For example, if you double-click on a keyword in the Master Keyword palette, any image with that keyword applied will appear in the Search Results gallery.

Once you have performed a QuickFind, the images that meet your search criteria will be displayed in the Search Results gallery.
Photo by Mike Tedesco/www.tedescophotography.com

Find

If you select the Find option from the Catalog menu, you will see a Find dialog box that allows you search any number of fields that are stored as metadata. In addition, if you click on the More Choices button, an additional search string will appear where you can do an 'And' or 'Or' search. You can add up to four additional search strings for any particular find operation. Note that if you have multiple catalogs stored on your machine, you can enable the 'Find in Multiple Catalogs' checkbox to search across all of your existing catalogs. In order to do this, each catalog you want to search must be opened. Once you have your search parameters created, click the 'Find' button to execute the search.

The Find dialog box enables you to search multiple fields to find exactly the images you are looking for.

iView MediaPro

Next, I will familiarize you with more image management features by discussing iView MediaPro. As with Extensis Portfolio, iView MediaPro operates using catalogs that store thumbnails and metadata about your images, so that you can effectively organize and efficiently search and locate specific images. Some of the features in MediaPro include: The ability to import images from Adobe Photoshop Album and Apple iPhoto, ICC color profile support for thumbnails in Microsoft Windows, improved scripting, and new RAW file support for a number of cameras. The basic features of MediaPro are covered with information you need to know in order to begin using the application.

Getting Started with iView MediaPro

One of the nice things about MediaPro is the help that it provides you, if you want or need it. Right from the start, you have a Getting Started wizard that will supply links to some basic information. It will also help you run your first import and get started organizing your images. From the initial screen of the wizard, you can bring up web pages on getting started, a tour of the features in MediaPro, and

some case studies that show how photographers have implemented iView MediaPro. You create your first catalog by importing images from a folder. If you enable the checkbox to Import from a Folder You Choose and click Next, you will be prompted to select the folder or files you wish to import. Once you have selected all of the items you want to import, just click the Import button and MediaPro will take care of the rest.

If you have already opened MediaPro once and closed the Getting

Figure 5.17 iView MediaPro provides an easy to use wizard to guide you through the process of creating your first catalog.

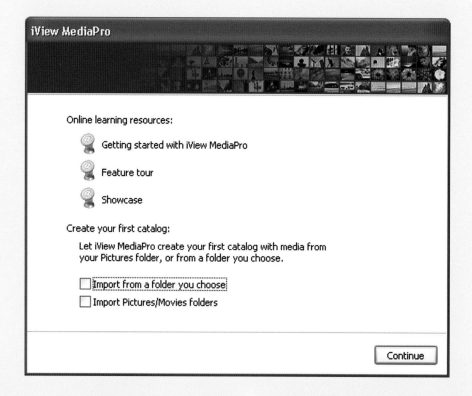

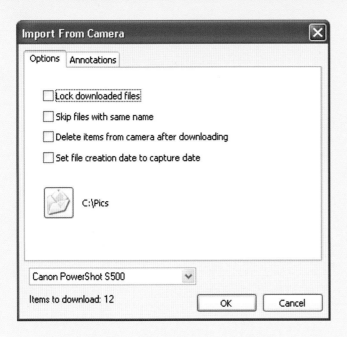

The Import From Camera dialog box allows you to set options for importing images directly from a connected camera.

Started wizard, you can run it again by clicking on the Help menu and selecting Getting Started...

In addition to importing files from the Getting Started wizard, MediaPro offers the following import options:

Import Items—If you use File > Import Items, you have the ability to import files from folders, from your camera (it must be connected), or from a URL.

Import from folders—Use the folder browser to navigate to a specific folder and select the images you want to import.

Import from your camera—If your camera supports the Picture Transfer Protocol (PTP), MediaPro allows you to import images directly from your camera into an existing catalog. (To determine if your camera supports PTP and to understand how to configure the protocol, refer to your camera's instruction manual.) In the Import From Camera dialog box, you have the ability to lock the files you've downloaded, skip files with the same name in case you left files on your card that had already been imported, delete files from the card after downloading (I recommend against this), and set the file creation date to be the capture

date. Within this dialog box, you also select the destination folder for the images that are copied from the card and you will see the number of images that will be downloaded. The Annotate tab allows you to enter some metadata that will be applied to each image being downloaded, such as author, copyright, status, and instructions.

The Import From URL dialog box enables you to enter a web address for images to download and import them quickly and easily.

Import from URL—With iView MediaPro, you can also download and catalog images from the Internet. In the Import From URL dialog box, you have to enter the entire path to the image including the extension (e.g. http://www.timgrey.com/timgrey.jpg). The image will be downloaded to your specified drop folder and then cataloged. Another way to catalog images from the Internet is to drag and drop an image from a web page to an open MediaPro catalog.

Add files from iPhoto—If you install the Mac version of iView MediaPro, you have the option in the Getting Started wizard to import images from an iPhoto library.

Add files from Adobe Photoshop Album—You can run a script that will import images from an existing Adobe Photoshop Album library. This script is located under Scripts > Import. Once selected, you just point the file browser to an existing Photoshop Album file and click Open.

Add files by Folder Watching—This feature works much like the Background Syncing option in Extensis Portfolio. You designate specific folders to watch and when images are added to the watched folders, they will be cataloged the next time MediaPro runs the Folder Watch. Unfortunately, the watch rate options in MediaPro are limited to every minute or every 5 minutes. I personally prefer the more

liberal set of options provided in Portfolio, as I don't need my folders synched quite so frequently.

Drag and drop—From any folder in your operating system, you have the ability to drag and drop an image or a set of images right into an existing MediaPro catalog.

MediaPro Preferences

iView has additional preferences that can be configured by going to Edit > Preferences. I will highlight a few key items under each tab:

General—As the tab is titled, you have a number of general configuration options such as sorting, warning pop-ups, how you want iView to startup, and finally what type of information you want displayed (dimensions, resolution, and date type).

Labels—In MediaPro, you have nine different colored labels that you can assign to your images for categorization. Within the labels tab, you can assign names to each of the nine colors to help you recognize the subject each color represents.

Scratch—MediaPro uses a scratch folder to store temporary versions of your open catalogs. These files are deleted once the catalog is either saved or closed. As a note, I recommend that the folder be placed on the fastest disk possible, and if you can, on a separate drive from the operating system disk.

Media—On the media tab, you can configure items, such as how thumbnails are generated, color matching (Windows only), and the size of files that MediaPro will catalog.

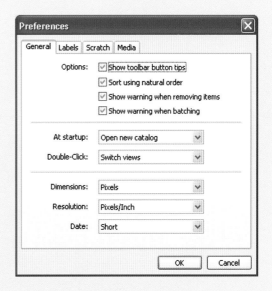

The Preferences dialog box in iView MediaPro allows you to customize many aspects of working with the program.

The Media Info section of the Info panel displays general file information about your image.

Info Panel

One of the first things that I noticed in iView MediaPro is the amount of valuable information that is presented to you in the default view. The area that I tend to access most is the Info panel. In other applications, you usually have to navigate to some sort of Properties menu to display this information. To access this data, be sure that the Info button is selected in the toolbar, which is the default in MediaPro. Some of the highlights of this panel include:

Media Info—This section displays general file information such as file type, encoding, file size, resolution, color space, etc. Some of this information is also displayed in the view panel (file type, dimensions, file size), which also displays the path to the file.

Photo EXIF—As covered earlier, EXIF metadata is information stored by the camera when you take a picture. Information found here includes camera model, date and time captured, lens used, focal length, aperture, shutter speed, ISO equivalent, etc.

Annotations—The Annotations section is actually the IPTC metadata and includes items such as title, copyright, location, URL, etc. This information is also stored and available in XMP metadata, which MediaPro can read from JPEG, TIFF, PNG, and Photoshop file types.

The Annotations or IPTC metadata will not be written from MediaPro back to the original file unless you enable the ability to synchronize the cataloged files with the original files. Whether or not you enable the synchronization really depends on your workflow. I usually add IPTC metadata prior to cataloging my images, so I generally don't modify this information after cataloging.

Annotations	
Title	Grace and Beauty
Product	-
Genre	Dancing
Event	-
Event Date	6-10-2005
Author	Mike Tedesco
Author Title	-
Credit	-
Source	-
Copyright	Tedesco Photography
Transmission	-
URL	-
Country	USA
State	-
City	-
Location	-
Instructions	-
Status	-
Writer	-

The Annotations section of the Info panel displays IPTC metadata.

Photo EXIF	
Capture Date	1/15/2005 8:44:48 PM
Aperture	f2.8
Shutter Speed	1/500 sec
Exposure Bias	+0.0
Exposure Prg.	Shutter Priority
Focal Length	130.0 mm
Flash	OFF - Compulsory flash...
Metering	Pattern
ISO Speed	1600

The Photo EXIF section of the Info panel displays equipment and exposure information for your image.

People/Keywords/Categories—These are additional Annotation or IPTC metadata fields that, again, can be very helpful in locating your images. To add this data to an image or a set of images, select the files you want this data added to and then double-click on the annotations section and add the new information.

Autofill—MediaPro allows you to save commonly used information so that you can then simply click a button and apply it to files after they are cataloged. To do this, you will need to select an image that has all of the annotation data you would like to save as an Autofill. Then, select the Pencil icon in the blue bar at the top of the Media Panel and click Save. You are prompted to give the Autofill a name. To apply an Autofill to new images, select the images and click the Autofill icon. Select the Autofill in the dropdown menu.

Favorites—This feature is a favorite of mine—no pun intended. MediaPro saves each annotation that you apply to an image. When you go to add an annotation to a file, just double-click in the appropriate field and you will see a list of all previous annotations used in that field. In addition, as you type, MediaPro will auto-complete if the word you are entering matches a prior annotation. This makes annotating your files a much faster process. The Favorites are also stored in a text file in the iView MediaPro plug-ins directory. You can use most any text editor to edit and add data to your favorites lists.

The Sync Annotations dialog box allows you to synchronize the annotations for your original images and the MediaPro catalog.

This can be very helpful as you first start cataloging images.

Sync Annotations—As noted earlier, annotations are only written to the MediaPro catalog and not the original files unless the files are synchronized. You also have the option to pull new information added to your original files to update the annotations of the cataloged files. To do this, select the Sync Annotations option from the Action menu. As always, use caution when overwriting data stored in your original files. Currently, MediaPro only supports the write back of annotation data to JPEG, TIFF, and Photoshop files.

Batch Processing

iView MediaPro provides a number of scripts that can be used to batch process groups of images. I think this is a huge benefit and can save a lot of time if you make use of this feature. There are four categories of scripts available under the Scripts menu:

Annotate—Under this menu, you have the ability to add keywords to multiple images, copy data to the clipboard and

paste it into another file or application, overwrite the IPTC caption field with the EXIF metadata, and use the image capture date in the Event Date field in the Annotations section.

Files—This menu has a single script that allows you to use the EXIF capture date information to rename the files selected. I perform my file renaming during image download, so this isn't something that I personally use, but again it depends on your workflow.

Import—The import option steps you through the process of converting an Adobe Photoshop Album into a MediaPro catalog.

Select—The select menu has two options: Landscape and Portrait. The landscape option will automatically select all horizontally oriented images in the current catalog, while portrait obviously selects all vertically oriented images. This script can be helpful in a situation where you need a particular subject and image orientation.

The Manage Color Profile dialog box allows you to apply or remove a specific color profile from an image. You might use this feature if you are printing images directly from iView MediaPro.

Color Profile Management

iView MediaPro now supports ICC color profiles for JPEG, TIFF, PICT, PDF, and Photoshop files. You are not limited to viewing color matched images in the media view, but can also see color profiled images in slide shows, thumbnails, and list view. In addition, you can select Action > Manage Color Profiles to apply a color profile to selected images. This is a really valuable feature if you are using your image management application to work with files prior to sending them for printing.

Getting Organized

An effective image management system is a much more robust solution
for keeping your images organized. These applications tend to cost more
and be more time consuming to setup and learn, but once the initial
learning is complete, these tools can be extremely helpful. I obviously
didn't cover every software solution out there. I encourage you to
research and review the features in each product and even download
and install the trials that most of these companies offer prior to making
your investment.

Chapter 6:
Internet Storage

The Internet has gone from something of a science project and hangout for computer geeks to a communications infrastructure relied on by many of us. The Internet enables us to quickly and easily access information all over the world. It also provides the ability to store information at remote locations with relative ease, which makes it worth considering as part of your overall storage strategy.

Remote Storage

The Internet is simply a network of many computers across the globe. Much like the global telephone network enables virtually any telephone to connect to any other telephone in the world, the Internet enables any computer connected to the network to share information with any other connected computer using appropriate software. Most of us are familiar with this concept because we take advantage of this connectedness to visit websites around the world, with each of those sites hosted on one of the computers connected to the Internet.

The way the Internet is configured provides a method for storing digital image files at a remote location that is relatively straightforward. The fact that the storage is remote is an important consideration. That aspect, along with the ubiquity of the Internet, is what makes this method worth considering—at least for some of your image storage needs.

Advantages

The primary advantage of the Internet is that it provides a method for you to store your images at a separate physical location. In fact, you could utilize the Internet to copy your images to multiple locations around the country or around the world. As you'll see in the next chapter on backing up your image data, having a copy of the data at a different location is a very good idea. If you lose the data on your hard drive due to a catastrophic event that occurs at your primary storage location, you'll want to be sure you have a backup copy stored elsewhere. The Internet enables you to store images at a remote location without leaving the comfort of your own computer chair. When implementing offsite storage as part of your backup strategy, you need to physically transport the media to a different location, which isn't nearly as convenient.

A related benefit of storing images on the Internet is that it is a two-way street. Not only can you send images to any other connected computer from

your personal computer, but you can also access those images from virtually anywhere in the world using any computer that is also connected to the Internet. That way, when you're traveling, visiting a client, or otherwise accessing your images from a different location, those images will be available.

Disadvantages

Of course, remote storage via the Internet isn't without its drawbacks. The most significant disadvantage is the amount of time required to upload your images. I'm sure you've experienced the frustration of waiting for a webpage to load into your browser, or the almost painful experience of waiting for particularly large files to download. For most users the situation is even worse when sending files.

Let's start off with setting a minimum bar for thinking about remote storage via the Internet. If you're using a dial-up Internet connection, this chapter really isn't for you. Dial-up is simply too slow for transferring large data files. That doesn't mean it couldn't be done, but

it is terribly inefficient and can be extremely frustrating. If you have high-speed Internet access available in your area, this would be a mandatory upgrade, in my mind, before you start using the Internet for storage purposes. Of course, there are still areas where dial-up is the only option available for connecting to the Internet, so if you don't yet have the option for high-speed Internet you'll just have to patiently wait and hope that it is available soon.

Even if you do have high-speed Internet access, you need to have realistic expectations about how fast you will be able to transfer data. Many high-speed Internet connections are asynchronous, meaning data is sent at a different rate than it is received. Since the focus of using the Internet is usually receiving rather than sending data, those asynchronous connections allow you to receive information faster than you send it. For example, a typical Digital Subscriber Line (DSL) high-speed Internet connection allows you to receive information at 768 kilobits per second (Kbps), but data is sent at a rate of 128Kbps. At these speeds, a 1MB file is received in about ten seconds, but requires about one minute to send.

Now consider a more realistic amount of data for the needs of a photographer. It would require about an hour and a half to upload about 100MB of images—your favorites from just one day of shooting. That isn't especially fast, which greatly reduces the desirability of using the Internet for remote storage. However, managed properly you can still overcome these performance issues.

Another potential drawback of using the Internet for remote storage is the cost. Granted, it isn't terribly expensive, but it is something to consider. There are a variety of options available for storage via the Internet, but for large capacity and the ability to update the data on a regular basis, the costs can add up. Costs will range from tens of dollars at the lower end to hundreds of dollars at the higher end.

Strategy

By evaluating the advantages and drawbacks of Internet storage, you can make a determination of whether it is an appropriate supplemental storage option for you. In short, if you have high-speed Internet access and your storage needs are relatively modest, the Internet is a good solution. If your storage needs are significant or you don't have high-speed Internet access available in your area, then it might not be an ideal choice.

If Internet storage does make sense, you can plan a strategy to optimize your approach to Internet storage to maximize the benefits and minimize the frustration. The first thing is to decide what role Internet storage plays in your overall storage strategy. I would not recommend at this time that you use the Internet as your primary storage solution. When blindingly fast connections are combined with extremely inexpensive storage options, this might be an option (though I think most photographers would still be leery, with good reason, about using the Internet as their primary storage). My feeling is that an appropriate role for Internet storage is to hold backup copies of your most important images, as well as provide access to those images from virtually anywhere around the globe.

You also need to consider what data you will actually store via the Internet. In addition to the drawbacks of slow

speed, there are typically limitations on how much data you can store or how much data you can transfer within a given period of time before surcharges apply. To keep your storage and data transfer requirements to a minimum, I recommend identifying the images that are most important to you, and therefore deserve to be backed up to a remote location. Which images are your favorites, represent the highest potential value, and are really the very best of everything you've ever photographed? Those are the images you should take special measures to protect. Remote storage via the Internet is an excellent additional backup method to protect these images.

Considering the limitations of using the Internet for remote storage, it simply doesn't make sense to transfer every single image you have ever captured and every file you have ever optimized. Instead, identify a subset of your images. That could mean making a special folder on your hard drive to store copies of your "signature" images so you can simply copy that entire folder to your remote storage location via the Internet, or it may mean

identifying the best images from each photo shoot and transferring them during the initial stages of organizing your most recent photos.

The bottom line is that while there are some inherent limitations involved with using the Internet for remote storage. An appropriate strategy will enable you to take advantage of the benefits while minimizing the frustration from the drawbacks. Having an extra copy of your most important image files stored at a remote location will provide you with additional peace of mind that your favorite photos will be safe regardless of the failure of one of your storage methods.

Storage Options

Once you've decided that it makes sense to utilize the Internet as a remote storage solution for your photos, you need to decide which specific storage option best meets your needs. There are several approaches you can take, each with their own advantages and disadvantages.

Site Hosting

A very common method of storing photos or other data via the Internet is to use a simple website hosting account. If you have your own website, you already have a built-in storage solution, so this might be a convenient option. However, you may need to upgrade your hosting account before using it for storage of your photos.

In general, the storage demands of a website are minimal. A website doesn't require a large amount of storage space, because it consists of text files along with images that are optimized to reduce their file size so website visitors won't grow frustrated with long download times.

The two key factors you need to consider in determining if a hosting account is appropriate for your needs is the amount of space available and the bandwidth usage limitations. The amount of storage space is a relatively straightforward consideration. You want to have a reasonable amount of space available so you can store at least all of your favorite images, and ideally an even larger collection of them. Even if you are limiting yourself to only your very best images, saving the high-resolution master versions of these photos can require considerable space, so you'll need to establish a website hosting account that provides an adequate amount of storage capacity.

Most standard website hosting accounts now offer around 100MB of storage. This, of course, is not very much for saving images. You'll probably want an account that provides considerably more storage. Many hosting providers offer plans that allow you to store tens of gigabytes of data, which is a much more reasonable capacity to enable you to store all of your very best images.

The other limitation is bandwidth usage, and this can be an issue if you will be updating the files stored on the server on a frequent basis. The idea of a bandwidth usage limitation is to ensure that a single user isn't dominating the resources of the server used to host the data. Bandwidth usage more commonly limits how many people can visit your website. More specifically, it measures how much data is downloaded by visitors to your site in the way of pages and images being viewed. However, most providers also count your uploads as bandwidth usage, so for the purposes of storing your images this can be a significant limitation.

In general, bandwidth limitations are presented as a volume of data that can be transferred on a monthly basis. With most providers the limitation is around ten to twenty times your total storage capacity, which means you could do ten to twenty complete updates of the data on the server without running into excess bandwidth usage charges. However, keep in mind that if you are using your website hosting account to actually host a website (and it certainly makes sense to utilize the hosting for both purposes), visitors to your website will be working against your total bandwidth usage. You'll need to be mindful of your own data transfer usage to stay within the bandwidth usage limitation.

Of course, this hosting is going to cost you something. While storage capacity and bandwidth are always changing, you'll generally find some similarity among pricing models from most providers. The starting prices for most hosting accounts provide a baseline of around 100MB of storage and modest bandwidth usage. By spending somewhat more you can get storage capacities in the range of 5 to 10GB with bandwidth usage of around 100 to 200GB. At the higher end, you'll

typically have storage capacity of about 50 or 60GB and bandwidth usage on the order of about a terabyte (1000 gigabytes) per month.

If you are going to use this option for your data storage, I recommend focusing on finding a provider that will meet your needs first and foremost for the hosting of a website. In my mind, this storage solution makes the most sense for those who already have or want to have a website to feature their photography. Therefore, find a provider that offers an account that meets your needs for a website, and then upgrade to a higher-level account that provides the storage capacity and bandwidth usage you'll need to be able to use the account effectively for storage of your best images.

You Get What You Pay For

You may be aware that there are a variety of web hosting options that are available for free. However, the limitations of these free accounts make them useless to photographers wanting to store images remotely. (In my opinion, they are barely sufficient for most users to maintain a website.)

The amount of storage space available with most free web hosting accounts is very limited, often on the order of tens of megabytes. (This may not even cover one of your images!) This is nowhere near enough space for you to store any significant number of images.

Even if a free web hosting provider does offer a good amount of storage space, there are other issues to contend with. The most critical of these is the likelihood that transfer speeds will be excruciatingly slow. Even if you have a high-speed Internet connection and are able to send data at a relatively high rate, that doesn't mean you will actually be able to send that data quickly. If the server is slow or bogged down trying to receive files from too many people at once, things will slow down considerably. Think of this as the classic bucket brigade for handing off buckets of water to put out a fire. If you have a single line of people passing buckets, things work pretty efficiently. If, however, you had three lines of people all passing buckets to the same person, things would slow down for each of the individual bucket lines. While the person receiving the buckets at the end of the line was grabbing a bucket from the first line, the other two lines would have to wait their turn. Similarly, most free providers don't provide the resources needed to ensure optimal performance.

Finally, I would be at least a little concerned about the reliability of a free web hosting provider. If they aren't earning money by providing these services, what is their incentive to provide safe, secure, reliable storage you can count on? I strongly recommend that you do some research to determine a hosting provider you can trust, and be willing to pay some money to utilize a remote storage solution for your valuable images.

Transferring Data

Once you have a hosting account set up, you'll need to have software to actually transfer the image data you want to store remotely. The process of doing so is exactly the same as transferring files for your website, so if you are already maintaining your own website this will be a natural extension of that work.

Transferring data to the server you're using for your hosting account is best accomplished using File Transfer

Protocol (FTP) software. This software allows you to establish a connection to the server and then transfer files to or from that server. The basic approach is that you first enter the details for your server, including the address provided by the hosting provider, as well as your user ID and password. You can then connect to the server automatically using those settings.

With the connection established, you are ready to transfer your data. Most FTP software enables you to do this by showing you a display of what is on your local computer on one side of the screen and the remote server on the other side. You can then simply navigate to the desired location on either side of the screen, and drag and drop files between them. Files can be transferred from your computer to the server and from the server to your computer. With some software you then need to click a button to initiate the transfer of data, though other applications start the transfer immediately. You can then use your FTP software to update the files stored on the server as frequently as you need to. After each photo shoot, or after a session of optimizing some of your favorite photos in Photoshop, you can simply copy them to your hosting server using the FTP software. I strongly recommend that you also set a schedule to review the files that are

FTP software enables you to enter your site hosting login details so you can gain access to the server for transferring data.

The typical FTP software interface allows you to see the contents of your local drive on one side of the display and the contents of the server environment on the other side. You can drag and drop between them to transfer files.

stored on your server and evaluate whether they still represent all of your favorite images. You may need to do this monthly if you capture a large volume of images, but for most photographers it would be appropriate to do this quarterly or even just every six months or so.

Of course, you don't want the whole world gaining access to your image files, so it is important to store them in a location that cannot be accessed by others. There are two things you can do here. The first is to store the files in a folder that is not linked to your actual website. You can do this by using your FTP software to create a folder on the server and giving it a name that people aren't likely to use as part of your website address. For example, on the server that hosts www.timgrey.com, I could create a folder called photos. However, then someone would just have to use the address www.timgrey.com/photos/ and they'd be able to

access any files I have stored in that location. While most web visitors don't go looking for "hidden" folders, you want to be sure they won't stumble upon them accidentally. For example, since I write books, I also wouldn't want to make a folder called "books" because it is reasonable to assume that a visitor might type in www.timgrey.com/books/, hoping to get directly to information on my website about the books I've written.

The safest way to secure your images is to password protect the folder where you store your data. This is actually the more critical of the two steps to take in protecting your data. In many cases the process of password-protecting a folder on the server can be a bit convoluted. I would recommend contacting your website hosting provider for information on how to do so. You might even want to request that their technical support department configure this for you if you aren't an advanced user familiar with the process.

There are countless FTP software applications available for you to choose them. A great resource for finding this and other software is the Tucows website (www.tucows.com), which

includes ratings for the software they provide for download. To help get you started, here are a few of the most popular FTP programs:

- BulletProof FTP (Windows only)
 www.bpftp.com
- Cute FTP (Windows only)
 www.globalscape.com
- Fetch (Macintosh only)
 www.fetchsoftworks.com

Storage Services

If you don't want to have a website, or would prefer to keep your website storage separate from your remote image storage, you may want to consider an Internet-based storage service instead. These are more straightforward in the sense that they are typically designed specifically for you to store data rather than for website hosting.

One of the more popular Internet-based storage services right now is Xdrive (www.xdrive.com). This service allows you to transfer files to your own storage folder using nothing more than a web browser. That means it is completely cross-platform and you can access your files from anywhere you're able to get online.

In most cases, the cost of a storage service will be lower than for a website hosting account. Therefore, it might make sense for you to use this type of service even if you will also have a website. For example, the annual cost for 50GB of storage is currently about the same amount you'd pay each month for a website hosting account with the same amount of storage.

In most cases a web browser is all you need (although some do utilize special software). Therefore they are typically even easier to use than the FTP software required for transferring files to a website hosting account. You generally either drag and drop the files you want to transfer or browse and select files you want to transfer.

Internet Backup

In addition to storage, you can also incorporate the Internet as part of a backup solution. Basically, it's an automated version of the storage solutions discussed already in this chapter. This is accomplished using software that automatically backs up the data you specify to the remote server. This adds a level of convenience, but unfortunately can add significantly to the cost. Compared to Internet storage, Internet backup solutions typically cost more than twice as much to store about half the amount of data. While such a solution does offer the advantage of automation, I personally don't consider the added cost to be worthwhile.

Screenshot courtesy of Xdrive

Web storage services, such as Xdrive, enable you to easily transfer files to the server using only a web browser.

This is especially true if you already have a good automated backup solution in place (and if you don't the next chapter will help you with that). Using the Internet for remote storage is really just a way of providing additional offsite storage for your most important images. Just remember it shouldn't be your only backup storage method. Therefore, I think it makes more sense to use one of the solutions discussed previously in this chapter, rather than using a more expensive backup solution that only adds value in the way of automation.

Storage at a Distance

The Internet provides some incredible resources, and it makes sense to utilize those resources for the purpose of saving copies of your most important image files in a remote location. This will give added peace of mind and can be an important part of your overall storage strategy.

Chapter 7:
Backing Up

Just because the topic of backing up
your data shows up at the end of this
book doesn't mean it isn't important.
It's just that you might want to
configure your backup system after
you've gotten started with the basic
organization of your images. Backing
up your data is a critical step toward
ensuring long-term access to your
digital photographs.

The Importance of Backup

There is no way I can convey in words how critically important it is for you to have a good backup system, and that you actually employ that system to ensure long-term reliable access to your photographic images. It is one thing to say you backup your images, and an entirely different thing to have a good system in place. When I give seminars and lectures on digital photography, I often ask how many people backup their images. Typically, about 90% of the hands go up. Then I test how good that backup system is. I ask them to keep their hands up if a hard drive failure would represent an inconvenience rather than a loss of images, most of the hands go down. This is a real problem!

I think it is important to mention again that digital photography provides a benefit in the way of being able to backup your images with an exact duplicate of the original. With film, you can create a duplicate, but there is always some loss of image quality. With digital it is possible to create a backup copy that is an exact replica of the original. Even a copy of a copy of copy is as good as the original.

With film, as long as you store the originals carefully and protect them from the elements, you don't have too much to worry about. If something does happen to the film though, the only image of original quality could be lost forever. Digital has some added risks, in that there are more opportunities for storage media to fail. That's why backup is so important. If you have copies of your images backed up properly, the loss of your originals will be an inconvenience, but not a tragedy.

While today's storage media is incredibly reliable, hardware and media can still fail. Let's hope you never experience a hard drive failure, but if you do you want to be sure you have a reliable backup and can retrieve your images. It is also important to backup your images

frequently, so you will have all your most recent digital photos available in the event of a loss of data.

I suppose I don't really need to explain how important it is to backup your images. I could simply tell you that backing up is only as important as your photographic images are to you. Most photographers I know have a tremendous emotional attachment to their images, and would do just about anything to ensure their safe storage. Backing up your data is a critical factor in doing just that.

Backup Options

There are many options when it comes to backing up your images. You can use a variety of media, software, and schedules with varying degrees of automation. The important thing is that you protect all of your photographic images by regularly saving copies. These copies should not be stored on the same media or device as the original images, as you would lose both sets of files if that media fails. Ideally, you should store the backup copy of your data in a separate physical location from the originals. For example, if you store your image library

at your studio, you might keep the backup set at your home. If there is a catastrophic incident (such as a fire) at the location where your originals are stored, it is important that a copy of your data be available in a different location. Even if that means you're keeping a backup in your vehicle outside your house, with the original image files in your house, find a way to keep your duplicate images in a separate location if at all possible.

Keeping a backup copy of your images stored in a separate location means that you'll need media that can be transported easily. You'll also need to have a system in place for backing up your data and taking it to a separate location. By reviewing some of these considerations, you can make a plan that works best for you to ensure access to your digital image files even if a storage device or media fails.

Backup Media

One of the first decisions you have to make when creating a plan to backup your digital photos is what type of media you'll use for backing up. The options include all the media types you would normally use for primary storage

of your image files, as well as certain media that are used exclusively for backing up large amounts of data. It is important to consider the advantages and disadvantages of each media type, as well as the relative convenience. Then you can determine a solution that works best for your particular needs. Let's examine the most popular storage media and consider some of the factors you'll want to think about when making a decision about which to use.

External Hard Drive

An external hard drive is actually my preferred method for backing up photos. There are a variety of advantages with this approach, including relatively fast speed in writing your data, high capacity in a single volume, and portability so you can easily transport the backup to a different location. If you're using an external hard drive for your primary storage, backing up to a second drive makes a lot of sense. You can simply copy an exact duplicate of the primary storage drive onto the second drive. It is obviously helpful to use drives of the same capacity when using this approach. My recommendation is that when you buy a new external hard drive to expand the amount of storage space

you have available for your images, you should buy a second one and designate it as the backup drive.

If you're using an internal hard drive or other media for your primary storage, you can still use an external hard drive for backup purposes. Just determine your storage needs based on the amount of digital image files you have already accumulated and the rate at which you expect to add to your library, and obtain an external hard drive that provides adequate storage capacity with room to grow. You should have already gone through this exercise in Chapter 1 when we looked at calculating your storage needs, but it is worth re-evaluating your needs when you are planning a backup strategy.

External hard drives are very reliable and durable, but they do fail and can be damaged. It is important to handle these drives carefully, but also important to keep in mind that failures are possible. As with any backup solution, you'll want to regularly confirm that the image copies transfer to the drive successfully.

One useful feature that is being included on some external hard drives is a button on the front of the drive that can be programmed to perform a specific software task. You can set it to

initiate an automatic backup of your drive, which can be very convenient. While you may want to schedule automatic backups to start at a specific time, this option adds one more degree of flexibility to your backup plan.

Optical Media

Optical media includes CDs and DVDs, and represents a good backup solution for some photographers. The biggest challenge for these media types is the lack of significant storage capacity in a single volume. CD media offers 700MB, current DVDs offer 4.7GB, and dual-sided DVDs offer 8.5GB of storage. Considering many photographers are using individual media cards in their camera that store one or more gigabytes of data, and considering how quickly those cards can be filled, it is clear that these capacities are no longer considered adequate for most backup purposes.

Many recent external hard drive models, including this OneTouch II drive from Maxtor, have a button on the front that can be programmed to launch a particular software application. This can make backup an easy one-touch task.

However, these optical media options can still be employed in a good backup strategy. For example, you could backup your images immediately after transferring them from your digital media cards used in the camera for capture. If you are using cards that are 512MB or smaller, the entire contents of a card would fit on a single CD. If you are using 4GB or smaller cards, a DVD can contain all of the images from a single card. This can be a good strategy in that it ensures you create a duplicate copy of your images immediately after capture, so even if you accidentally delete images during the sort/edit process, you can still recover them.

Of course, if you only back up immediately after downloading the images you have captured, then you won't have copies of the other versions of your images. If you update the image metadata with image management software or alter files with image-processing software, you'll want to protect the work you've done. That means you will want to backup all of the data you are creating related to the images, and organizing that to fit on individual optical media can be a challenge. Burning many discs at once can be very laborious and time-consuming. If you burn a new backup disc every time you make a change to an image, you can quickly find yourself with an overwhelming number of disks to store.

For all of these reasons, I recommend that optical media only be used for supplemental backup purposes. For example, if you're working on a particular project and want to make an extra backup of the files being used or you want another backup copy of your important images, optical discs provide a good solution. The fact that they are so ubiquitous is also an advantage, because you know it will be easy to find a computer that can read the data you've backed up onto the media.

Tape

Tape drives and media got their start many years ago as a primary storage device, but now are used almost exclusively for backup purposes. These drives use a tape cartridge and special drive to record data (Figure 7.2). While the concept is very similar to other removable storage media, tape is different in that the tape is "linear" and must be moved forward or aft to find the right position. Other media, by contrast, enables very quick access to any particular piece of data stored on the device. This represents one of the biggest disadvantages of using tape for storage. You can't access the data directly and copy individual files with the same ease with which you can perform that task with other media types. When using a tape drive, you must use special software to access and recover data. While the result is still an ability to both backup and restore your critical data, this factor creates a minor barrier for many users who feel more comfortable when they have a duplicate copy of their data that is easily accessible without the need for special software.

Another issue that has become a significant problem for tape drives is limitations on capacity. Tape drives

actually provide greater capacity than optical media, so this obviously isn't a major limitation. However, because of the way tape drives are typically used, to backup large amounts of data, this limitation is actually more significant. With optical media you can find ways to divide your data to make appropriate use of the space and the images are stored on ready-to-read media. You would use a tape drive for backing up data when you need to have more significant storage capabilities.

The mid-range tape drives (costing several hundred dollars) provide storage of around 40GB depending on the type of tape cartridge used. Higher capacity drives that sell in the one to two thousand dollar range allow capacities of around 200GB. While this is significantly more than optical media provides, a hard drive can provide the same amount of storage space at a considerably lower price. If you have a significant amount of data to backup, you would need multiple cartridges to perform a single full backup. Even incremental backups, where you only backup the data that has been added or changed since the last backup, can quickly span across multiple tape cartridges. When multiple cartridges are required for a single backup job, it

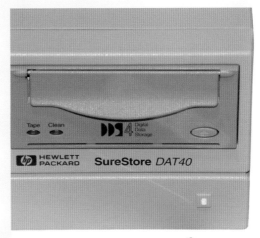

Tape drives use cartridges to record data during the backup process.

means you need to swap cartridges after the first becomes full, causing an interruption in what could have otherwise been an automated backup. Despite the disadvantages, tape backup does offer a fast solution that is dedicated to a single task, and many people utilize this type of backup reliably.

Internet Backup

As you learned in the last chapter, copying data to a server on the Internet can be a very time-consuming process. While using a service that allows you to copy or backup data to a remote server includes the benefit of an offsite storage location, the speed issue is significant. Even with a high-speed Internet connection, it can take hours to upload one gigabyte of data. While a gigabyte is a huge amount of data from the perspective of the Internet, it is not very much for digital photography. A backup to local media for each gigabyte of data can take less than a minute with most external hard drives, for example. Therefore, while Internet-based storage can be helpful for storing key files, it isn't an optimal solution for backing up large amounts of data, even on an incremental basis, because of performance issues. Also keep in mind that if you use your Internet connection for a backup, it will be very slow for any other purposes, such as browsing the web or checking e-mail, until the data transfer is complete.

Software Considerations

There are a variety of software applications you can choose from to backup your data. They allow you to copy, upload, and/or download data automatically on schedule from your computer to whatever type of storage media you use. A program may either mirror your data by copying it as is or collect all the data to be backed up into an archived file. Some software offers both options.

Backup software has been around for a long time, so most of the popular options today are very reliable. Therefore, the primary considerations when choosing a particular backup application is ease of use and feature set. In many cases you might not even choose backup software by comparing various options, since your drive or media used for backing up might come with software. For example, many tape drives include backup software, and you'll find several external hard drives that also include backup software in the package.

Usability can be difficult to evaluate without actually using the software. Fortunately, in many cases

you can download a preview of the software before buying it. This gives you an opportunity to get to know the software and decide if it is a good solution for your needs.

One of the issues you may want to consider when choosing backup software is how data is handled. Does the program simply copy your files to a designated location or does it package all of your data into a single proprietary backup file? If you only have the latter choice, your access to files is somewhat restricted. You won't be able to browse the backup data and recover individual files as easily. If you accidentally discard an image or some of your data is corrupt, it can be a bit of an ordeal to recover a single file. To open a proprietary backup file, you'll need to

first run the backup software again (reinstalling it if you are recovering from a hard drive crash on your computer) and then process the file using the restore operation. If you do experience a loss of data, it is much easier to recover your images if all you need to do is connect the drive or insert the media and gain immediate access to your images. There are advantages to backing up data into a single archived file. Usually some compression is applied, so the data requires less storage space. Some people rarely need to access copies of their images and prefer to have their entire backup archived into a single file.

The following are some of the available backup software applications you might want to consider. This is only a partial list, as there are many

Choose backup software that provides the features you need and a good user experience. Dantz Retrospect is available for both Windows and Macintosh and is an application I highly recommend.

applications available. However, these are applications that I feel offer strong features and good usability. Reviewing these options would be a good way to begin your search if you need to purchase backup software.

- Dantz Retrospect (Windows and Macintosh) www.dantz.com
- Veritas Backup Exec (Windows only) www.veritas.com
- NTI Backup Now! (Windows only) www.ntius.com
- Argentum Backup (Windows only) www.argentum.com
- Acronis True Image (Windows only) www.acronis.com
- Backup4All (Windows only) www.backup4all.com

Any of these applications will help you backup your important data effectively, with the only real difference being the interface, user experience, and particular options provided by each. By doing some research based on your own needs and preferences, you can find the right backup solution for you.

Backup Schedule

I often get asked about how frequently a backup should be performed. I think it is pretty safe to say that in many cases the right answer would be, "More often than you are now." The way I look at performing backups is similar to the concept of saving any document I am working on. Whether I'm writing a new chapter for a book or making adjustments to an image, I frequently save the work in progress. If there is a problem with my computer that causes the application to quit, I can revert to the last saved version and hopefully won't have to redo too much of my work. Therefore, after any task that involves significant time or effort, I save the file.

Similarly, with backups you should think about how much data you're willing to lose if you experience a hardware or media failure. Chances are your answer is, "None." It therefore makes sense to backup on a regular and frequent schedule to ensure that if you experience a loss of data, your backup will contain everything you need.

There are two basic methods related to scheduling for backing up your image data backups, which I refer to as scheduled backups and manual backups. Let's take a look at these and consider how they might both fit into your backup strategy.

Scheduled Backup

The most important reason to perform a scheduled backup is that it removes the burden of remembering to backup. Without an automated backup application operating on a set schedule, it is quite likely that you'll start to fall out of the habit and you won't be effectively protecting your data. I like to relate this to working out at the gym, which is another one of those tasks most of us know we should do but

many of us don't do enough (myself included). If I had someone scheduled to stop by my house three days a week, put me into a car and take me to the gym for a workout, I'd be in much better shape. Similarly, you want to have an automated backup schedule so you don't even have to think about performing a backup – it just happens for you automatically.

Most backup software will allow you to schedule automated backups (Figure 7.4). You simply configure the software by telling it what data to backup, where to put the backup files, and when to start the process. Then you make sure the computer is left on during the time the backup is scheduled, and that the backup media is available.

Most backup software will allow you to schedule automated backups, as shown here with Dantz Retrospect Professional.

It is easy to say that you need to backup often, but you should figure out a specific schedule if you're going to configure software for an automatic backup. The ideal time between backups will vary from one photographer to another. When in doubt, I would recommend that you run a backup every single night. However, if you travel frequently or might go a week or more without capturing any new images or modifying any existing ones, it might make sense to adjust your backup accordingly. There's no sense in repeating a backup to the same media for a week straight when that data hasn't changed at all.

Therefore, look at the frequency with which you add or update images and set your backup schedule to fit. That might mean you backup twice daily, daily, weekly, or even monthly. The key is to perform a backup often enough to ensure that if your primary storage failed, it would only be an inconvenience with no image data actually lost.

The other consideration is when the backup should be performed. My recommendation is to have the backup conducted late at night, after you are likely to have finished working for the day. I don't recommend having backup software run at the start of the day. If you suddenly need to get something done early in the morning, your computer will either be tied up performing a backup or will process very slowly and you'll have to interrupt the backup to get work done. Interrupt that backup too often and it becomes much less useful. So, consider your own schedule, what time you're most likely to be finished working each day, and how long the backup takes to perform. (The length of time varies with the amount of data to be backed up. Once you've run a backup a few times you'll know about how long it takes.) For most photographers, starting the backup around midnight or two in the morning is a good solution, but if you're a night owl you might need to find a different time.

Once you've identified a backup schedule that works, configure your backup software to perform your backups based on that schedule, and you should feel much more comfortable about the safety of your digital photos.

Manual Backup

As you can probably imagine, I don't recommend relying upon a manual

backup for your important images. There is a chance that you'll get out of the habit and not perform regular backups often enough to provide adequate protection for your images. However, at times it can be important to perform a manual backup in addition to your regularly scheduled backups. For example, if you're in the middle of a critical project, you might want to backup more frequently than your scheduled backup calls for. Or if you've just downloaded a large number of photos from a recent shooting trip, you may want to immediately make copies of those images before reformatting your CompactFlash cards rather than wait for the next backup to be performed automatically. To perform a manual backup, simply launch your backup software and use the command to start a backup immediately rather than relying on your scheduled backup.

Verify Your Backup

No matter how frequent your backups, how much you trust your software, and whether you're doing a scheduled or manual backup, it is always a good idea to verify that the backup is working properly. Even if you observe that your backup starts every night, you should

verify that the data is being written successfully, and that all of the correct data is included. For example, if you store your images in multiple locations, you should verify that each location is being backed up properly. I've known photographers who felt perfectly confident with their backup system and had an automated backup run every night. But they turned off the warning messages in the software, never verified their backup, and weren't very happy to learn months later that the backups weren't being performed successfully.

To verify your backup, browse the contents of the drive or media where you are backing up your data. If your software writes a proprietary file, use the restore option to confirm that all the data is actually there. You'll want to restore the data into a test folder to make sure you're able to read the data successfully. Don't overwrite the data in the original folders, as it may have changed since the last backup.

The bottom line is that you can never be too careful when it comes to backing up your digital photos. Create a strategy for backing up that will protect your data and regularly confirm that it is operating properly so that your data is indeed protected.

Offsite Storage

As I mentioned earlier in this chapter, storing your backup at a separate physical location will help you avoid the most catastrophic causes of data loss. It is important to incorporate a plan for offsite storage into your backup strategy. At the very least, you can use an Internet storage solution, as discussed in Chapter 6, to protect your most important images, but such a solution may not be practical for your entire library of digital photos.

Instead, I recommend taking your backup media to a different physical location on a regular schedule. If you are backing up to optical media or a tape backup, you can simply take the media to your offsite storage location. If you're using external hard drives, this may not be as practical, as you'll need to continually take the drives offsite for safe keeping but then bring them back onsite to refresh the backup to include the latest new images and other updates. In this situation, it is common to get into a situation where you're bringing the external drive back and forth so much, and it seems to be

onsite more than it is offsite, that you fall into the trap of simply deciding to keep the drive onsite permanently, eliminating the potential benefit of an offsite backup.

If you're using external hard drives, you might even want to consider having two backup drives for each one original. That way, at all times you can have a drive offsite. The primary drive would be onsite permanently, and at any given time one backup drive would be onsite so you could refresh the backup, and one would be offsite for safe keeping. This naturally adds to the expense of backing up your images, but if you ever need to restore from an offsite backup you'll consider it a good investment.

The bottom line is that there's no such thing as being too careful when it comes to backing up your digital photos. The more you can do to ensure the safe storage of both the original data and your backups, the better off you'll be. Storing a backup at a separate physical location is just one more step you can take toward protecting your images.

Safe and Sound

Once you have created a system for backing up your digital photos and are actually following that system regularly, you can feel confident that your images are safe. That way, when you experience a hard drive failure or other cause of lost digital images, you'll be able to restore your data with minimal fuss, never having to worry about which images you might have lost forever. If an image was worth taking in the first place, it is worth protecting!

Glossary

aberration
An optical flaw in a lens that causes the image to be distorted or unclear.

acuity
The definition of an edge between two distinct elements in an image that can be measured objectively.

Adobe Bridge
A basic browser application that provides rating and labeling features for the purpose of digital photo management.

Adobe Photoshop
Professional-level image-processing software with extremely powerful filter and color-correction tools. It offers features for photography, graphic design, web design, and video.

Adobe Photoshop Elements
A limited version of the Photoshop program, designed for the avid photographer. The Elements program lacks some of the more sophisticated controls available in Photoshop, but it does have a comprehensive range of image-manipulation options, such as cropping, exposure and contrast controls, color correction, layers, adjustment layers, panoramic stitching, and more.

AI
Automatic Indexing.

angle of view
The area seen by a lens, usually measured in degrees across the diagonal of the film frame.

anti-aliasing
A technique that reduces or eliminates the jagged appearance of lines or edges in an image.

artifact
Information that is not part of the scene but appears in the image due to technology. Artifacts can occur in film or digital images and include increased grain, flare, static marks, color flaws, noise, etc.

artificial light
Usually refers to any light source that doesn't exist in nature, such as incandescent, fluorescent, and other manufactured lighting.

astigmatism
An optical defect that occurs when an off-axis point is brought to focus as sagittal and tangential lines rather than a point.

asynchronous
Over the Internet, data is sent at a different rate than it is received.

available light
The amount of illumination at a given location that applies to natural and artificial light sources but not those supplied specifically for photography. It is also called existing light or ambient light.

backlight
Light that projects toward the camera from behind the subject.

backup
A copy of a file or program made to ensure that, if the original is lost or damaged, the necessary information is still intact.

bit
Binary digit. This is the basic unit of binary computation. See also, byte.

bit depth
The number of bits per pixel that determines the number of colors the image can display. Eight bits per pixel is the minimum requirement for a photo-quality color image.

bracketing
A sequence of pictures taken of the same subject but varying one or more exposure settings, manually or automatically, between each exposure.

brightness
A subjective measure of illumination. See also, luminance.

buffer
Temporarily stores data so that other programs, on the camera or the computer, can continue to run while data is in transition.

byte
A single group of eight bits that is processed as one unit. See also, bit.

card reader
Device that connects to your computer and enables quick and easy download of images from memory card to computer.

CCD
Charge Coupled Device. This is a common digital camera sensor type that is sensitized by applying an electrical charge to the sensor prior to its exposure to light. It converts light energy into an electrical impulse.

chromatic aberration
Occurs when light rays of different colors are focused on different planes, causing colored halos around objects in the image.

chrominance
A component of an image that expresses the color (hue and saturation) information, as opposed to the luminance (lightness) values.

chrominance noise
A form of artifact that appears as a

random scattering of densely packed colored "grain." See also, luminance and noise.

CMOS

Complementary Metal Oxide Semiconductor. Like CCD sensors, this sensor type converts light into an electrical impulse. CMOS sensors are similar to CCDs, but allow individual processing of pixels, are less expensive to produce, and use less power. See also, CCD.

CMYK mode

Cyan, magenta, yellow, and black. This mode is typically used in image-editing applications when preparing an image for printing.

color balance

The average overall color in a reproduced image. How a digital camera interprets the color of light in a scene so that white or neutral gray appear neutral.

color cast

A colored hue over the image often caused by improper lighting or incorrect white balance settings. Can be produced intentionally for creative effect.

color space

A mapped relationship between colors and computer data about the colors.

CompactFlash (CF) card

One of the most widely used removable memory cards.

complementary colors

In theory: any two colors of light that, when combined, emit all known light wavelengths, resulting in white light. Also, it can be any pair of dye colors that absorb all known light wavelengths, resulting in black.

compression

A method of reducing file size through removal of redundant data, as with the JPEG file format.

contrast

The difference between two or more tones in terms of luminance, density, or darkness.

contrast filter

A colored filter that lightens or darkens the monotone representation of a colored area or object in a black-and-white photograph.

CPU

Central Processing Unit. This is the "brains" of a computer or a lens that perform principle computational functions.

critical focus

The most sharply focused plane within an image.

cropping

The process of extracting a portion of the image area. If this portion of the image is enlarged, resolution is subsequently lowered.

default

Refers to various factory-set attributes or features, in this case of a camera, that can be changed by the user but can, as desired, be reset to the original factory settings.

depth of field

The image space in front of and behind the plane of focus that appears acceptably sharp in the photograph.

download

The transfer of data from one device to another, such as from camera to computer or computer to printer.

dpi

Dots per inch. Used to define the resolution of a printer, this term refers to the number of dots of ink that a printer can lay down in an inch.

DPOF

Digital Print Order Format. A feature that enables the camera to supply data about the printing of image files and supplementary information contained within them. The printer must be DPOF compatible for the system to operate.

dye sublimation printer

Creates color on the printed page by vaporizing inks that then solidify on the page.

EXIF

Exchangeable Image File Format. This format is used for storing an image file's interchange information.

Extensis Portfolio

Image management software focused solely on enabling the user to organize and catalog digital images, usually working with many images at once.

FAT

File Allocation Table. This is a method used by computer operating systems to keep track of files stored on the hard drive.

file format

The form in which digital images are stored and recorded, e.g., JPEG, RAW, TIFF, etc.

filter

Usually a piece of plastic or glass used to control how certain wavelengths of light are recorded. A filter absorbs selected wavelengths, preventing them from reaching the light sensitive medium. Also, software available in image-processing computer programs can produce special filter effects.

FireWire

A high speed data transfer standard that allows outlying accessories to be plugged and unplugged from the computer while it is turned on. Some digital cameras and card readers use FireWire to connect to the computer. FireWire transfers data faster than USB. See also, Mbps.

firmware

Software that is permanently incorporated into a hardware chip. All computer-based equipment, including digital cameras, use firmware of some kind.

full-frame

The maximum area covered by the sensitized medium.

full-sized sensor

A sensor in a digital camera that has the same dimensions as a 35mm film frame (24 x 36 mm).

GB

See gigabyte.

gigabyte

Just over one billion bytes.

GN

See guide number.

gray card

A card used to take accurate exposure readings. It typically has a white side that reflects 90% of the light and a gray side that reflects 18%.

gray scale

A successive series of tones ranging between black and white, which have no color.

guide number

A number used to quantify the output of a flash unit. It is derived by using this formula: GN = aperture x distance. Guide numbers are expressed for a given ISO film speed in either feet or meters.

hard drive

A contained storage unit made up of magnetically sensitive disks.

histogram

A graphic representation of image tones.

icon

A symbol used to represent a file, function, or program.

image-editing program

See image-processing program

image-processing program

Software that allows for image alteration and enhancement.

interface

The point of interaction and communication with operating systems, software, applications, etc.

interpolation

Process used to increase image resolution by creating new pixels based on existing pixels. The software intelligently looks at existing pixels and creates new pixels to fill the gaps and achieve a higher resolution.

IPTC

Stands for International Press Telecommunications Council. A body responsible for defining the standards for image and image text; most importantly, the standard describes the inclusion of information such as captions, credits, and keywords.

IS

Image Stabilization. This is a technology that reduces camera shake and vibration. It is used in lenses, binoculars, camcorders, etc.

ISO

From ISOS (Greek for equal), a term for industry standards from the International Organization for Standardization. When an ISO number is applied to film, it indicates the relative light sensitivity of the recording medium. Digital sensors use film ISO equivalents, which are based on enhancing the data stream or boosting the signal.

iView Media Pro

Image management software that enables the user to organize and catalog many digital images with ease.

JFET

Junction Field Effect Transistor, which are used in digital cameras to reduce the total number of transistors and minimize noise.

JPEG

Joint Photographic Experts Group. This is a lossy compression file format that works with any computer and photo software. JPEG examines an image for redundant information and then removes it. It is a variable compression format because the amount of leftover data depends on the detail in the photo and the amount of compression. At low compression/high quality, the loss of data has a negligible effect on the photo. However, JPEG should not be used as a working format—the file should be reopened and saved in a format such as TIFF, which does not compress the image.

KB

See kilobyte.

kilobyte

Just over one thousand bytes.

latitude

The acceptable range of exposure (from under to over) determined by observed loss of image quality.

LBCAST

Lateral Buried Charge Accumulator and Sensing Transistor array. This is an

array that converts received light into a digital signal, attaching an amplification circuit to each pixel of the imaging sensor.

LCD

Liquid Crystal Display, which is a flat screen with two clear polarizing sheets on either side of a liquid crystal solution. When activated by an electric current, the LCD causes the crystals to either pass through or block light in order to create a colored image display.

LED

Light Emitting Diode. It is a signal often employed as an indicator on cameras as well as on other electronic equipment.

lithium-ion

A popular battery technology (sometimes abbreviated to Li-ion) that is not prone to the charge memory effects of nickel-cadmium (Ni-Cd) batteries, or the low temperature performance problems of alkaline batteries.

lossless

Image compression in which no data is lost.

lossy

Image compression in which data is lost and, thereby, image quality is lessened. This means that the greater the compression, the lesser the image quality.

low-pass filter

A filter designed to remove elements of an image that correspond to high-frequency data, such as sharp edges and fine detail, to reduce the effect of moiré. See also, moiré.

luminance

A term used to describe directional brightness. It can also be used as luminance noise, which is a form of noise that appears as a sprinkling of black "grain." See also, brightness, chrominance, and noise.

Mac

Macintosh. This is the brand name for computers produced by Apple Computer, Inc.

macro lens

A lens designed to be at top sharpness over a flat field when focused at close distances and reproduction ratios up to 1:1.

main light

The primary or dominant light source. It influences texture, volume, and shadows.

MB

See megabyte.

Mbps

Megabits per second. This unit is used to describe the rate of data transfer. See also, megabit.

megabit
One million bits of data. See also, bit.

megabyte
Just over one million bytes.

megapixel
A million pixels.

memory
The storage capacity of a hard drive or other recording media.

memory card
A solid state removable storage medium used in digital devices. They can store still images, moving images, or sound, as well as related file data. There are several different types, including CompactFlash, SmartMedia, and xD, or Sony's proprietary Memory Stick, to name a few. Individual card capacity is limited by available storage as well as by the size of the recorded data (determined by factors such as image resolution and file format). See also, CompactFlash (CF) card, file format.

menu
A listing of features, functions, or options displayed on a screen that can be selected and activated by the user.

metadata
Data that is used to describe other data.

microdrive
A removable storage medium with moving parts. They are miniature hard drives based on the dimensions of a CompactFlash Type II card. Microdrives are more susceptible to the effects of impact, high altitude, and low temperature than solid-state cards are. See also, memory card.

middle gray
Halfway between black and white, it is an average gray tone with 18% reflectance. See also, gray card.

midtone
The tone that appears as medium brightness, or medium gray tone, in a photographic print.

mode
Specified operating conditions of the camera or software program.

moiré
Occurs when the subject has more detail than the resolution of the digital camera can capture. Moiré appears as a wavy pattern over the image.

MOSFET
Metal Oxide Semiconductor Field Effect Transistor, which is used as an amplifier in digital cameras.

nested folders
On a computer, folders contained within folders.

noise

The digital equivalent of grain. It is often caused by a number of different factors, such as a high ISO setting, heat, sensor design, etc. Though usually undesirable, it may be added for creative effect using an image-processing program. See also, chrominance noise and luminance.

operating system (OS)

The system software that provides the environment within which all other software operates.

original capture

The original image taken directly from the memory card of the digital camera.

pan

Moving the camera to follow a moving subject. When a slow shutter speed is used, this creates an image in which the subject appears sharp and the background is blurred.

PC

Personal Computer. Strictly speaking, a computer made by IBM Corporation. However, the term is commonly used to refer to any IBM compatible computer.

perspective

The effect of the distance between the camera and image elements upon the perceived size of objects in an image. It is also an expression of this three-dimensional relationship in two dimensions.

pincushion distortion

A flaw in a lens that causes straight lines to bend inward toward the middle of an image.

pixel

Derived from picture element. A pixel is the base component of a digital image. Every individual pixel can have a distinct color and tone.

plug-in

Third-party software created to augment an existing software program.

polarization

An effect achieved by using a polarizing filter. It minimizes reflections from non-metallic surfaces like water and glass and saturates colors by removing glare. Polarization often makes skies appear bluer at 90 degrees to the sun. The term also applies to the above effects simulated by a polarizing software filter.

RAID

Stands for Redundant Array of Independent Disks. A mulitple set of hard disks normally mounted in a single enclosure. Critical data is simultaneously written to multiple disks to improve the read/write performance and reduce the risk of data loss in the event of a single disk failure.

RAM
Stands for Random Access Memory, which is a computer's memory capacity, directly accessible from the central processing unit.

RAW
An image file format that has little or no internal processing applied by the camera. It contains 12-bit color information, a wider range of data than 8-bit formats such as JPEG.

RAW+JPEG
An image file format that records two files per capture; one RAW file and one JPEG file.

rear curtain sync
A feature that causes the flash unit to fire just prior to the shutter closing. It is used for creative effect when mixing flash and ambient light.

red-eye reduction
A feature that causes the flash to emit a brief pulse of light just before the main flash fires. This helps to reduce the effect of retinal reflection.

remote storage
Storing data in a separate physical location.

resolution
The amount of data available for an image as applied to image size. It is expressed in pixels or megapixels, or sometimes as lines per inch on a monitor or dots per inch on a printed image.

RGB mode
Red, Green, and Blue. This is the color model most commonly used to display color images on video systems, film recorders, and computer monitors. It displays all visible colors as combinations of red, green, and blue. RGB mode is the most common color mode for viewing and working with digital files onscreen.

saturation
The degree to which a color of fixed tone varies from the neutral, grey tone; low saturation produces pastel shades whereas high saturation gives pure color.

sharp
A term used to describe the quality of an image as clear, crisp, and perfectly focused, as opposed to fuzzy, obscure, or unfocused.

slow sync
A flash mode in which a slow shutter speed is used with the flash in order to allow low-level ambient light to be recorded by the sensitized medium.

small-format sensor
In a digital camera, this sensor is physically smaller than a 35mm frame of film. The result is that standard

35mm focal lengths act like longer lenses because the sensor sees an angle of view smaller than that of the lens.

TB
see terabyte

terabyte
Equivalent to 1000 gigabytes.

format uses lossless compression.

TTL
Through-the-Lens, i.e. TTL metering.

USB
Universal Serial Bus. This interface standard allows outlying accessories to be plugged and unplugged from the computer while it is turned on. USB 2.0 enables high-speed data transfer.

vignetting
A reduction in light at the edge of an image due to use of a filter or an inappropriate lens hood for the particular lens.

viewfinder screen
The ground glass surface on which you view your image.

VR
Vibration Reduction. This technology is used in such photographic accessories as a VR lens.

Wi-Fi
Wireless Fidelity, a technology that allows for wireless networking between one Wi-Fi compatible product and another.

XMP
Created by Adobe, stands for Extensible Metadata Platform; is a means of grouping metadata together to make for more efficient workflow.

Index